PAINTING THE UNPOSED FIGURE IN WATERCOLOR

DESIGN
BOOKS
INTERNATIONAL

PAINTING THE UNPOSED FIGURE
IN WATERCOLOR
© 2001 by Design Books International

First published in Spain by
Parramón Ediciones, S.A. 1996
as FIGURA A LA ACUARELA
Text, illustrations and photographs © Parramón
Ediciones, S.A., 1996, World Rights
Text: David Sanmiguel
Artist: Vicenç Ballestar
Collection design: Toni Inglès
Graphic design: Josep Guasch
Photographs: Nos and Soto

First published in the U.S.A. by
Design Books International
5562 Golf Pointe Drive, Sarasota, FL 34243
E-mail: designbooks@worldnet.att.net

Distributed by
North Light Books
An imprint of F&W Publications, Inc.
1507 Dana Avenue
Cincinnati, OH 45207 USA
TEL 513-531-2222 TEL 800-289-0963

ISBN 0-9666383-3-6

05 04 03 02 01 5 4 3 2 1

U.S. Edition
Edited by Herbert Rogoff
Production by SYP Design & Production
Translated by Ellen King-Rodgers

Printed and Bound in Spain

PAINTING THE UNPOSED
FIGURE IN WATERCOLOR

Written by David Sanmiguel
Illustrated by Vicenç Ballestar

Published by Design Books International, Sarasota, FL
Distributed by North Light Books, Cincinnati, OH

Contents

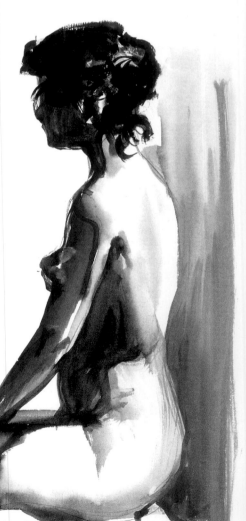

*T*he book that you are holding is the realization of my life-long dream. To be able to pass along to you what I know of the painting craft is the fringe benefit.

Composition, tone (light and shadow) and color are basic elements; they regulate and form the substance of painting, and they have remained the same after centuries of paintings by masters throughout every culture. In the case of this book, the elements concentrate on interpreting the human figure. They will express themselves through the medium of watercolor.

Now you are ready to face the human figure. You will learn to express with your brush the various attitudes and emotions you will run into. These will be in the attitudes of movement, gesture, and rhythm, into which you will inject the emotions of happiness, loneliness, weariness and tranquility. And these will suggest timidity, compassion and sensuality.

You will paint the activities of working, resting, talking, dancing, and walking. The mood of the subjects will not be as a result of poses, because there is not a pose in this book. All of our people have been photographed or sketched while going about their business, and they were not aware of it. Each figure's attitude is totally spontaneous. This is the principle throughout this book; the point of view beneath that which pictures the figure. A kind of "Candid Brush."

Everywhere in our daily lives, many scenes and ideas about people loom up before our eyes. Knowing how to observe with artists' eyes offers us refreshingly different scenarios to be painted with watercolor: spontaneous, alive, full of sentiment and joy that will thrill the paintings' viewers. Just think of the wealth of opportunities: the vitality of a child playing in the street, the fatigue and hardness reflected in the tanned, leathery skin of a farmer returning from work, the tenderness between a loving couple strolling in the park, the animation of a group of people in discussion around a table at a bar, the mystery of what that person on the bus is thinking, the loneliness of a homeless person who sleeps in the street, the innocence of a sleeping baby. All of them ready, each and every day, to be captured in photographs or even rough

sketches for later development at a quieter moment in a quieter place — your studio.

We're very proud of this book. The star of this project, however, has to be Vicenc Ballestar, a master of the technique of watercolor and a figure painter of great ability. His uncanny ability of observation and the ease of his rapid rough sketches will help you to be more conversant with figure painting. In every sketch and step-by-step demonstration, Vicenc's words will guide you through the lessons.

I hope you find that this book will help you to observe with the eyes of an artist. I hope, too, that you will then be able to record the many inspirations that intrigue you.

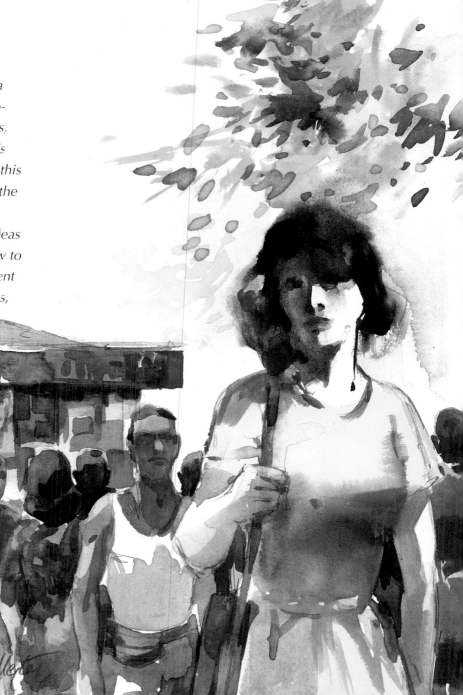

Materials

TYPES OF WATERCOLORS AND PALETTES

Watercolor paints are available in two varieties: blocks of semi-moist watercolors and the far more popular tubes of watercolor. The colors in blocks are generally sold in sets of various assortments and made by some manufacturers. The easily accessible watercolor tubes are sold in sets and also separately; they require a palette—either in metal or plastic—that contains wells to hold the color. The metal containers are made of white enamel. In recent years their utility has fallen into disfavor as more and more plastic palettes have appeared on the scene. They are lighter than metal, easier to clean and do not rust. Metal palettes, after much use, may eventually rust. Your art material dealer will have a number of plastic palettes from which to choose.

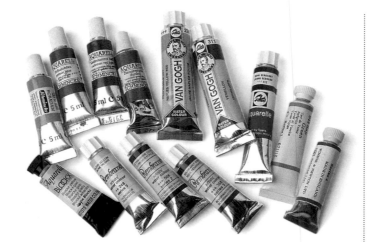

Pictured here are tubes from many manufacturers of fine watercolor paints. You will find a difference in price from tube to tube due to the relative expense of the pigments. Cadmium colors are generally the more expensive colors of the palette; earth colors, such as Burnt Sienna, Burnt Umber, Yellow Ochre, etc., are less expensive.

This is a typical set of semi-moist colors. The blocks of paint are replaceable and can be bought separately. Similar sets are available from other color makers but they are not as popular among today's watercolorists as are tubed watercolors.

The illustrator of this book, Vicenc Ballestar, uses the materials that are shown in the picture above. As you can see, he prefers to use the metal palette. You can also see the colors in their wells and the mixing area above them. The artist's brushes have been carefully selected; they are capable of painting areas from thin lines to wide, bold strokes of color.

Plastic has become the most popular material for watercolor palettes. It makes palettes that are light in weight and rust proof. They come in all sizes and mostly with more mixing area than is shown here.

PAPER

The best—and most expensive—watercolor paper is hand-made using linen and cotton rags. For your practice studies, buy the cheaper paper, some of which can be bought at a fraction of the cost of handmade. All paper is available in pads, blocks and individual sheets, size 22" x 30". Paintings that are painted on this size are referred to as "full sheet." Popular weights of paper range from 72-pound to 300-pound. These numbers are based on the weight of a 500-sheet ream of paper. Texture in watercolor paper is extremely important.

The three textures of watercolor paper are: Hot pressed (HP) — smooth; cold pressed (CP)— rougher in texture and used by most watercolorists; rough (R)— grainier than cold pressed. A full sheet of paper can be mounted on a board with clips or can be tightened damp over a board.

Watercolor paper comes in separate sheets, pads or blocks, a variety of sizes and weights, and in three major textures.

Upon drying, the paper is ready to paint on. When the session is over, the dried watercolor painting can be detached from the board with hardly any warping. You may also affix your paper to the board with sealing tape. See the picture at the bottom of this page.

BRUSHES FOR WATERCOLORS

The best brush for watercolor painting is made of red sable from the marten (or Siberian mink) whose habitat is the Kola Peninsula, thus the name Kolinsky. This variety of watercolor brush is extremely resilient, yet costly. Less expensive, but capable of giving you excellent service, are brushes made of ox hair, material that comes from the ears of the oxen. They have good snap (or resiliency) and are popular among many watercolorists. Other reasonably-priced brushes are made from the hair of squirrels' tails, as well as from man-made hair (synthetics). Three brushes made of red sable or oxhair in sizes 8, 12 and 14 and one or two of synthetic hair in larger sizes can paint any watercolor. To these one can add a larger flat brush with soft hair that's made in Japan.

This is all you'll need for your painting: Two red sable (smallest sizes), one oxhair, one chisel-edge (synthetic), and a hake (pronounced hockey) Japanese soft hair blender.

The clips and pins are invaluable accessories for work with watercolor. The paper should be well supported; when one works with an individual sheet of paper, this support is a wooden board; when one works with paper in a block, the support is the heavy cardboard block.

Sponges are a great help for dampening paper to extend color or "rub out" a damp spot. They are also very handy for cleaning your palette at the end of your work session. Pure sponges, though expensive, are better than the synthetic varieties.

Using watercolor paper in larger sizes, you'll want to tighten it while damp before painting. Fix it to a board with sealing tape. After you've finished and the painting has completely dried, cut the painting from the board with a razor blade.

ADDITIONAL UTENSILS

Apart from the basic materials mentioned, the watercolorist uses a number of auxiliary materials such as: utensils for drawing, like pencils to get the preliminary drawing, erasers, a knife or cutter, adhesive tape, clips, pins, paper towels or rags to dry and clean the paintbrushes, sponges and water containers, preferably large and with wide openings.

This is the way that watercolor paper stays taut while taped over a board.

Equipment for the studio

Artists' portfolios, relatively inexpensive, are handy to use to keep your watercolor paper from any damage. They are also good for storing your paintings.

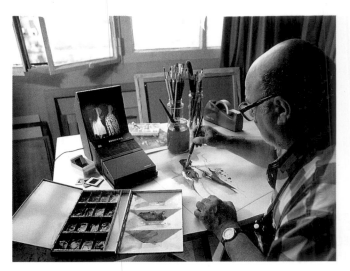

SPACE AND UTENSILS

In the studio, you will need a table large enough to work on and to hold all your materials, and folders for storing your paper. The table should have drawers to hold extra materials, boxes, palettes, paintbrushes, etc. You can make a good table with a piece of plywood and two or three sawhorses. There are a great variety of adjustable drawing tables, but they are expensive.

You will want the standard drawing materials, such as pens, pencils and bottles of ink. Moreover, you should have on hand drawing paper or small pads

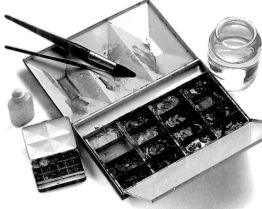

Handy to have is a projector that you will need to enlarge 35mm slides. The one shown above is moderately priced.

The artist's palette, its wells filled with juicy color, is seen in the picture to the left. Nearby is a cup of water, and resting on the mixing side of the palette are two brushes, a small red sable and a squirrel mop for large areas.

of note paper for sketching all kinds of ideas and for trying out possibilities for paintings.

Paper, blank or painted on, should always be kept flat, never rolled. A chest of drawers in your studio is ideal to protect your paper, but these cabinets are expensive and take up a lot of space. Use, instead, portfolios of various sizes.

For your light source, necessary for every artist, the best is natural light from windows with shades or curtains that permit you to regulate your light. Supplementary light from a lamp is a must.

A camera is absolutely essential for you to paint the unposed figure. The one we see here is a 35mm single lens reflex (SLR), but any modern camera will do.

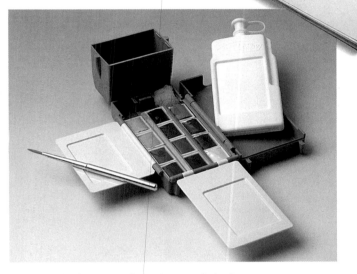

For working in the street, the most comfortable way of transporting paper is in spiral bound pads. These pads are available in many sizes and paper qualities for painting water-color sketches. You should have a notebook for color notes and reminders. For larger pieces, you may use bound blocks of paper or separate sheets fastened with thumb-tacks on a backboard.

EQUIPMENT FOR PAINTING ON LOCATION

The equipment that you will need for outdoor (or street) painting should be a smaller version of what you would have in your studio. You'll need a small box of watercolors, a small container with a screw-top lid for water, and paper that you will have to cut into quarter sheets. You may also want to have a watercolor block or pad of the same size. To carry all this gear, you can choose from an assortment of canvas tote bags.

Carrying brushes should be no problem. A mailing tube cut down to size makes the perfect brush carrier. It can hold all of the brushes that you feel you need on the street. Finally, you'll want your sponges, pencils, erasers and razor blades.

This is a perfectly compact box palette. Its design incorporates a surface for mixing, a small bottle and a receptacle for the water and a disassembled paintbrush.

The paintbrush has an aluminum handle that acts as a hood to protect the hair, which is usually sable in these smaller brushes. You may have difficulty getting these items, but try to do so, it will be worth your while.

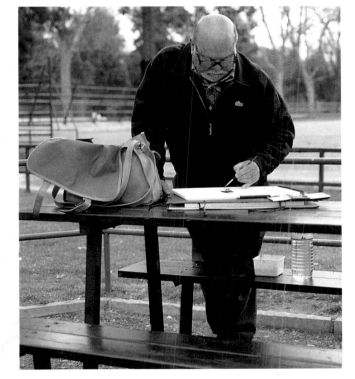

Any tote bag will do to carry your equipment. Shown here is a hunter's tote which has compartments for the many kinds of materials that you want to have always ready for your use.

STEP-BY-STEP

Working with Photographs

MOTHER AND CHILD IN THE PARK

A camera in the hands of a figure painter is indispensable. After all, the artist has to get with accuracy a moving figure in what would be, without the use of photographs, a very rapid sketch. The danger of using photography, as you are probably aware, is the tendency for the artist to duplicate the photograph literally. Since this is the first of many photographs you will see in this book, I have to stress at this point how important it is to edit out extraneous material that shows up in the photographs. Study carefully the three shapshots that are reproduced here and then compare them to the way they were handled in the artistic rendition. In this demonstration, we see a young mother and her son in a children's park.

■ **HELPFUL HINT**

Even though three photos are shown in this demonstration, in reality, I shot an entire roll of 36. It is far better to take a lot of them than too few. The more photos you take of a scene the more possibilities you will have to select a combination of figures.

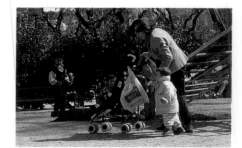

1 The impact of the scene is captured right in the pencil sketch. You can see that the drawing presents a movement of figures that doesn't relate to any one photo. To inject the spontaneity that is needed in a project such as this, the drawing is not a faithful representation. Instead, it is an interpretation of all the graphic material, which will lead, in following steps, to a presentation that is free of slavish reliance on photographic reference.

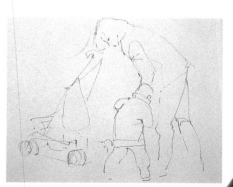

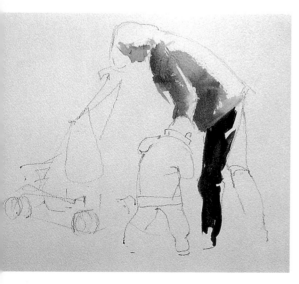

2 The mother, as you can see, is the focal point of this composition. Her figure is painted in first to establish the key for the painting. Mixtures of Burnt Sienna and blue (complements) are used for her slacks and this same mixture, diluted greatly to create a gray, is used for her jacket.

STEP-BY-STEP

3 The hair and the spot of the flesh color in the face are painted in. They don't correspond with any of the photos. What we see is really based on a general vision of the three photos. There is no attempt to strike a likeness to the model.

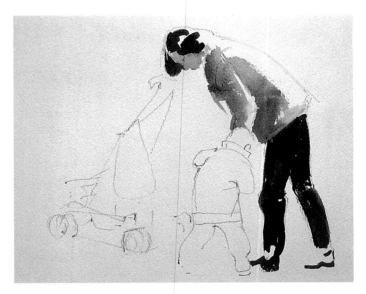

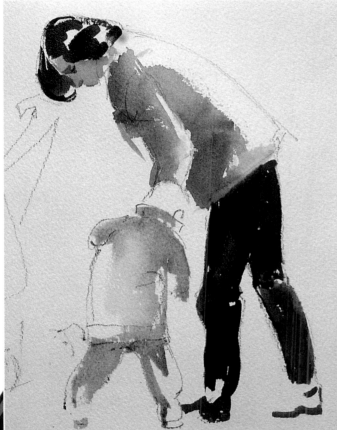

4 The boy is now painted. At this stage, he is a splotch of color, almost a general idea. His figure has been created by reference to one of the photos and also by memory and knowledge of what a little boy's attitude should be.

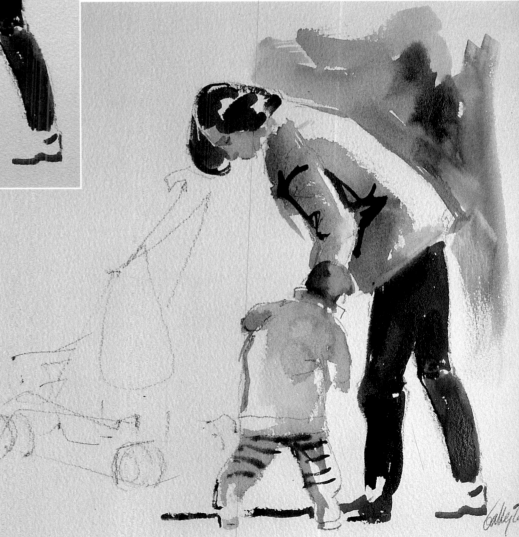

5 The finished result, which is as far as I wanted to go in this painting, presents a freshness that belies its photographic motivation. The technique of the brushstroke, the block of color, and the tonality of the piece is a beautiful example of how one should work from photographs and still retain free creativity.

STEP-BY-STEP

Working with Photographs 2

THE CLEANING WOMAN

As I have already stated, painting from photographs is mainly a matter of deciding what to take out and what to leave in. Even though you may have a photograph that seems to be satisfactory, it is rare indeed to use it just as is for your painting. Looking at the photograph of the cleaning woman, the first thing you notice is that the broom handle divides her head in two. Of course, it will have to be moved when the drawing for the painting is sketched in. The rest of the figure works well and, as a result, will be transferred to the watercolor paper just as it shows up in the photograph.

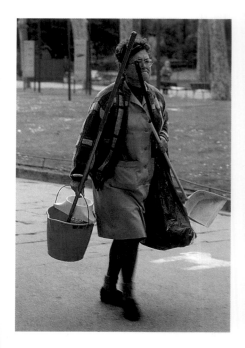

1 The amount of drawing that I've done in this stage is all you need to do at this point. Make your pencil sketch a definitive guide for your painting but do so with few extraneous strokes. What's important to keep in mind is that you are not making a pencil drawing but merely pencil indications that serve as scaffolding for the painting to follow. It stands to reason that if your subject matter is more complicated, such as the depiction of buildings in which the accuracy of the architecture is important, or machinery and other devices which require more detail, then all of those particulars would have to be rendered with much more care.

2 The basic concern when one works with photographic images is not to add the details too early in the process. Over the general sketch, paint in the color of the flesh, garments, and equipment to assure yourself that the harmony is correct and the relationship of the tones is balanced. You can see in this step that a fair amount of the pencil drawing still shows through the initial lay-in of color.

■ HELPFUL HINT

The difficult thing for watercolor beginners to do is to keep their pencil indications light. While it's perfectly all right for pencil marks to show through the color, they must never be intense enough to distract the viewer's eyes from the painting strokes.

STEP-BY-STEP

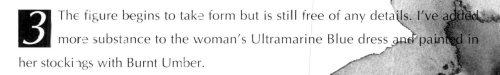

3 The figure begins to take form but is still free of any details. I've added more substance to the woman's Ultramarine Blue dress and painted in her stockings with Burnt Umber.

4 Since solutions to the earlier problems of harmony of color and the values of light and shadow have been taken care of, we can now begin to think of the details. The amount of detail in this picture isn't much: the print of the cleaning woman's jacket, the broomsticks, her eyeglasses and little else.

5 I have added some more details, like the buttons of the dress, the hands and some other minor things before calling the watercolor finished. The degree of being finished is dictated by how much of the photograph you would want included. It's obvious in this painting that the result is a sprightly interpretation of the source material.

The Quick, Rough Sketch

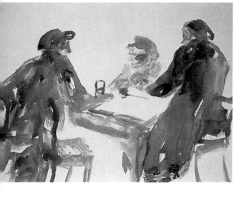

Emile Nolde (1867-1956), In the Inn, watercolor on paper. This is a sketch from life that the artist did rapidly. You can see that the spontaneity of the painting left no room for corrections, if there were to be any. All the strokes were set down as Nolde's automatic response to the color and the actions of the scene.

MARGINAL NOTES

Artists' studios teem with sketches that were done on papers that were handy to the artist at a particular time: books, newspapers, even train tickets. Most of all, paper napkins of some bars and restaurants are always available for the artist who, while waiting for his meal or coffee, makes good use of his time sketching what he sees or recording fantasies which may enter his mind at that moment. Consequently, painters start to accumulate an immense quantity of material of this type. Even though a major part will remain forgotten in the boxes and folios, a small percentage will provide the impetus for a major work. It is typical that the artist may have happy realizations when, upon thumbing through the old folios, he comes upon one or more of those sketches that brings to mind some interest of the moment and may, perhaps, be used for some future work. But even if these sketches are never used, it's not lost work, because the painter has already reaped the benefits. Doing rapid sketches is the best pastime for the figure painter.

A BASIC QUESTION

The quick, rough sketch is the basis of figure painting, as we will deal with it in this book. All of the figure renderings begin with one or a few quick sketches. The quick sketch itself will either be the definitive work or it can be a preparation for a larger, more ambitious effort. In any case, the sketches are all important because they are the firm supports that are behind the very being of the works that are represented.

To my way of thinking, figure drawing takes up the most space in artists' sketch books. Observing a figure—at home, at work, on the street, etc.—and making impressions of these candid moments can provide for some artists the basis for larger pieces of work. For others, the sketches become finger exercises, keeping their hands at

it, so to speak. The importance of these sketches, however, is that there are many images in our memories from which we can draw when we are called upon to do so. Some artists are lucky for they have the ability to keep in their memory images to put down, with great fidelity, on paper.

Henri de Toulouse-Lautrec (1864-1901), Bruant on a Bicycle, oil over cardboard. Museum Toulouse-Lautrec, Albi. Toulouse-Lautrec had great facility with drawing and painting the figure, which is evident in this sketch. He put his knowledge of the human figure to great advantage. Toulouse-Lautrec sketched constantly, at cafes, in brothels and, mainly, at the Moulin Rouge nightclub, his favorite haunt.

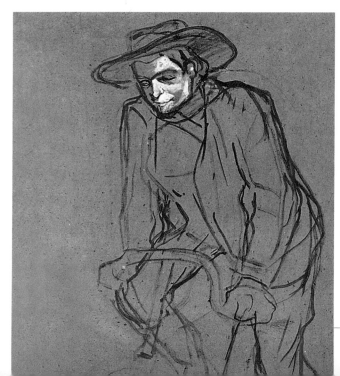

The lifelike sketch, very rapid and spontaneous, should always be breezier than the apparent freezing of the reference photograph. As you can see here, the sketch possesses a vitality that, while characterizing the photograph, has in the very nature of the way it is painted, an exciting presentation of a live figure in motion. Compare the sketch with the photo to see the changes that I made.

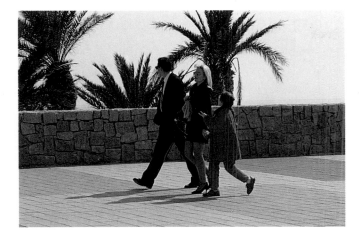

Watercolor is a marvelous medium for quick sketches. No other procedure can give you the attractive, impulsive look when it is used in the manner shown in the sketch at left. The colors have been boldly socked in which produces clean, sparkling-fresh color.

Looking at the photo, you can see the changes that Ballestar made. The quick strokes of the brush—a large one—make it easy to remove the "photographic look," the curse that seems to dog most amateurs. I can't tell you strongly enough the necessity of establishing your sketch as a piece of original art instead of as a literal copy of the photo.

The rapid watercolor sketch can be a form of drawing, except that you're not using a rigid drawing instrument. Instead, you're using a brush. Fortunately, the thick, soft texture of the brush makes it hard to "draw" details. This leaves you only with the problem of establishing the attitude, the pose and the movement of the figure.

THE TRUE VALUE OF SKETCHES

Artists' sketchbooks have always had great value as inspirations for larger, more important compositions. Consider paintings of the old masters. They began with sketches, most of which are displayed in museums throughout the world. Sketches of more contemporary artists are considered collectibles as well. We can appreciate the freshness and the freedom of execution that are characteristic of sketches, and in today's climate of collecting mania, sketches are being viewed in the same aesthetic light as more important pieces. We must not lose sight of the true value of preliminary sketches as either supporting actors in a major piece, or as brightly painted decorations.

NEW THEMES

A figure painter deals with the portrayal of human beings, and the attitudes of the models are wildly diverse. The painter, therefore, has to be conversant with the nuances of the human figure, which is shown in this sketch. In the perspective that I used for the head and shoulders, it's easy to see how much an artist has to understand foreshortening. Taking notes, with words and pictures, permits the painter to be able to be comfortable in any situation at any time.

Capturing the Gesture

WHAT THE GESTURE SAYS

Figure painters talk constantly about gesture (or attitude): how to capture it, how to value it, how to give it significance. When we speak of gesture we speak of what makes a figure have life and personality. We don't want the figure to be an object to copy but a theme to recreate. What else does gesture tell us? The figure in its form is alive. And by saying "gesture" we do not only refer to the expressions of the face, but the entire body. Each person has a way of walking, a way of standing and sitting, a way of being. Capturing the gesture—or attitude—is capturing a personality in its most elementary way.

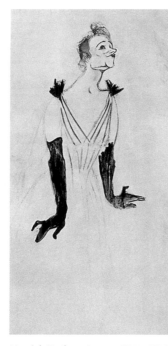

Henri de Toulouse-Lautrec (1864–1901), Yvette Gilbert in the Act of Reciting, charcoal with oil outlines. Museum Toulouse-Lautrec, Albi. This figure is all about gestures. The motions of the face, arms and hands, to those who knew her, were as much a likeness as the features of her face.

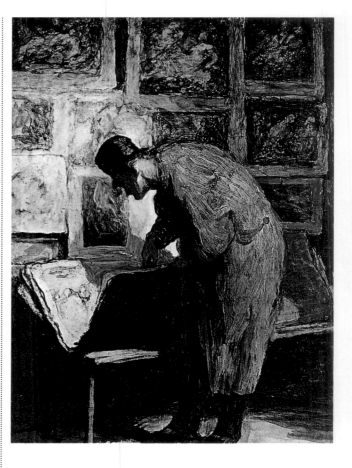

Honore Daumier (1808-1879), Man Looking at a Folio, oil over board. Philadelphia Museum of Art. The characterization of a figure of a personality does not have to delineate any features of the face. The attitude and gesture of the figure can be individual and personalized through attention to movement or attitude.

Jules Pascin (1885-1930), Men, Women and Children, watercolor. Collection Bellier, Paris. A perfect example of the skill in catching the characteristic gestures through some small outlines and blocks of color.

REPRESENTING GESTURES

When you draw a sketch of a solitary figure or a group of them, you have to ask yourself questions that differ from those you would ask when painting a landscape or still life, which are paintings of inanimate objects.

With the human figure, you are concerned with gesture, which is not synonymous with anatomy. In fact, a sketch or drawing that has a successful gesture might very well, at the same time, be anatomically incorrect. In the movement of the figure, in the spontaneity of the moment, certain deformities of the figure, while wrong from an anatomist's standpoint, could do the job admirably as a rapid sketch that depicts a body in motion. Landscape and still life painters have to paint their objects just as they are unless they have in mind the distortion of all objects in their compositions.

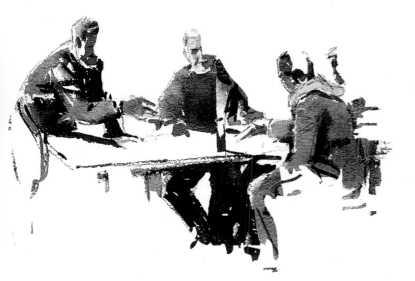

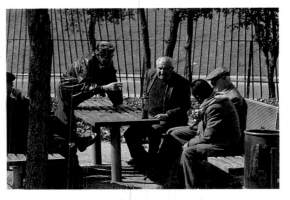

When one works with natural life, it is important to secure the attitudes of each personality to get a complete portrait of the scene. The background and details have been omitted. They do nothing to enhance the figures.

PLAYING WITH PROPORTIONS

In the course of studying to draw the human figure we constantly are faced with a chart that shows the way to proper proportions—usually rigorous constructions. We can't deny how vital this element of drawing is. But we have to be aware that the figure is a live form, making gestures every minute of the day. This is at the heart of what we're trying to do in this book: infusing life to a figure.

Students should study and practice all the time so they can then feel comfortable in daring to distort a figure and to play with proportions, varying them for the sake of the figure in action. There will be times when you will find the need to enlarge an arm or leg, to exaggerate the curve of a shoulder or to tone down unnecessary details. Don't worry about the academic consequences of what you're doing; the dynamism of the figure is all important. The finished result—a figure in valid movement—will be your satisfaction and reward.

This example illustrates the idea of good characterization as a result of the significant gesture of a personality and not as a frozen moment. Look at the four photos. While the sketch is closest in attitude to the photo at top left, you can't really say it is an exact copy.

The gesture of a waiter at a sidewalk cafe makes an intriguing subject. Everyday gestures characterize and give personality to the figure.

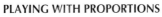

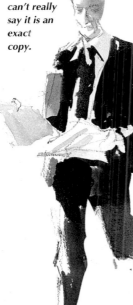

Combining the Components

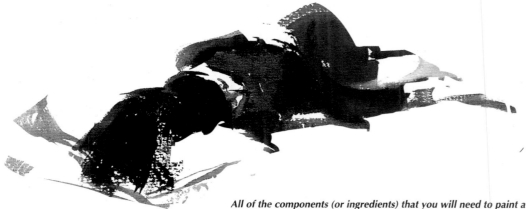

All of the components (or ingredients) that you will need to paint a successful sketch—drawing, tone, color and a spirit of brushwork—are brought together in this interpretation of a figure.

ESSENTIALS

Essential in all forms of art is being able to pull from your memory an image of what you will represent on paper. Of enormous practical use for the figure painter is the knowledge of components that are absolutely essential for picture making. They permit the artist to quickly brush in a figure spontaneously; a figure or scene that contains all that is necessary for the enjoyment of the viewer. Starting here, the painter can unfold the work profoundly or merely leave it as a sketched or drawn plan.

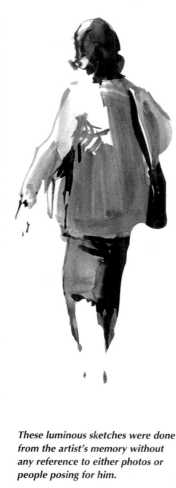

These luminous sketches were done from the artist's memory without any reference to either photos or people posing for him.

Eugene Delacroix (1798-1863), Sketches, ink on paper. The Louvre, Paris. The French painter's pen-and-ink sketches, marvelously free-spirited, were drawn largely without the use of source material, attesting to the value of a knowledge of drawing and anatomy.

■ **HELPFUL HINT**

The breeziness of the sketches seen here comes with experience. Looking closely, you can see the attention being paid to anatomy, proportion, and color. Largely, though, the spirit is in the brushwork; the dexterity can only come from a lot of practice. The fresh, clean color you see on these figures is a result of a quick laying-in of color. It is also characteristic of watercolor since in order to get this same effect with oils, the color would appear to be diluted. Used opaquely, (the addition of white paint), the brilliance seen here would be somewhat reduced. It's interesting to note that the Delacroix pen-and-ink drawings do with penlines what the watercolor brush accomplishes in the color pieces.

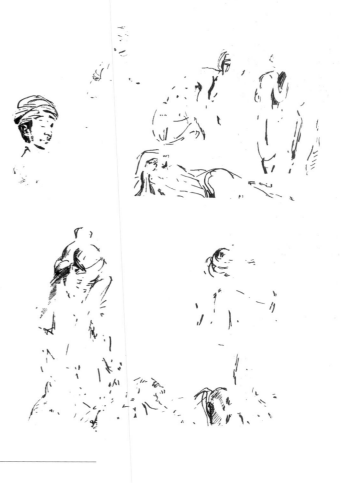

Line as a medium of the representation of the figure can do much to express freedom in the doing of rapid sketches. The artist used a brush in these sketches, and while it did not hinder the movement and vitality in the figures, it also managed to inject, due to the thick-thin quality of the brush line, a dimension of depth.

THE CHARACTER OF LINE

To get the character of the line, you can practice two types of exercises: 1) working with a very fine utensil (a small pen or a ballpoint) or 2) working with something very large (a felt pen, a stick of charcoal, or a paintbrush). In the first case, one must work quickly, without shading, only following the forms of the theme through the continual line that suggests form. In the second case the question is to establish the figure or figures through few lines that suggest the use of light and dark. Both procedures correspond to two distinct attitudes: the artist may adopt one or the other according to what fits his personality, or may use both as the mood strikes.

Working with many small steps obliges one to give maximum expression and the best visual value to the lines and sketches. In this sketch in line and sepia watercolor washes, the thicknesses of the lines are very important and each one of them is indispensable in the final resolution.

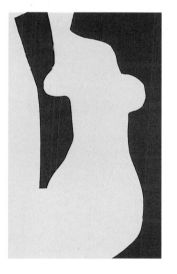

Henri Matisse (1869-1954), Venus, collage on paper. National Gallery of Art, Washington. An extreme example of a rendition of the human figure. The torso of this Venus is the white background that was created by two cutouts of blue paper.

USING MONOCHROMATIC COLOR

In painting a monochromatic watercolor sketch the tone can be sepia, which is always attractive. Actually, any other color can be used. Values of gray, for example, can be very rich. The monochromatic color can contain a variety of tones. By the use of pressure on the brush and the ratio of water to pigment, the artist could translate the colors of the scene in value contrasts. If a sketch is well valued monochromatically, it won't be difficult to interpret it in color in a bigger piece. As a sketch in its own right, a monochromatic sketch has its own special attractiveness.

Edouard Vuillard (1868-1940), A Meal in the Village, pastel on paper. Art Gallery and Museum, Glasgow. In spite of the realistic approach in this painting, the figures in this scene are represented with a few blocks of color.

Andre Derain (1880-1954), Danza Baquica, watercolor on paper. Museum of Modern Art, New York The chromatic and lineal qualities of this watercolor result in a decorative effect. The tree is stylized to coincide with the movement of the figures.

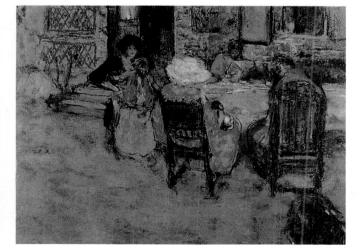

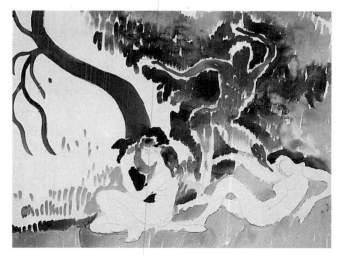

Significant Details

Auguste Renoir (1844-1919) Harvest. The Louvre, Paris From a piece of a garden, Renoir creates a delicate watercolor which is sketch-like in treatment but can, because of its beauty of color and luminosity, be considered to be a complete work. The countryesque details are important; they function to enhance the fresh youth of the model.

TIME FOR DETAILS

Up to this point, we have been looking at sketches that functioned well without any adornment in clothing or environment. At this stage, we will investigate the addition of important details that we find we will need for the purposes of identification and further edification. After all, the people in our sketches will look and feel more comfortable with homey touches. Does this mean that every composition will now be major in scope? Not at all. We can still retain the extemporaneous character while injecting meaningful detail into our sketches.

THE ELEMENT OF ENVIRONMENT

Much like the scenic designer of a theatrical production, you have to place your cast of characters in environments that are plausible. It is up to you to decide how much or how little paraphernalia to add to your sketches. To help you decide, just remember that you are a figure painter and that the figure must dominate your composition. Therefore, you don't want to create a picture that's heavily involved with furnishings, if indoors, or landscape, if outdoors.

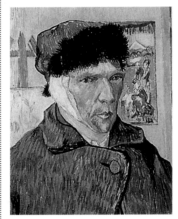

Vincent van Gogh (1853-1890), Self Portrait, oil on canvas. Courtauld Institute, London. Van Gogh felt the need to add some small details in the background. There are just enough here to establish the setting for this sad self portrait as the artist's studio.

THE ATMOSPHERE

The suggestion of atmosphere in which we want to immerse the figures can be created through the inclusion of everyday objects or through the use of blocks of colors, lines and forms for an abstract treatment. In this case, the artist can paint contrasting colors that represent flowers. That goes for any other type of object. The freedom of the creator is paramount. The artist can interpret the atmosphere in any manner that suits the painting.

Beth Shadur, Don't Burn Your Bridges Behind You, gouache watercolor on paper. Private collection. In this work of fantasy, an imaginative vision based, very probably, on the experience of the artist, the details almost devour the scene and serve to give dreamlike character to this work.

Auguste Renoir, In the Boat, watercolor on paper. Museum of Fine Arts, Budapest. The brushstrokes that suggest the shore are details that help explain the scene.

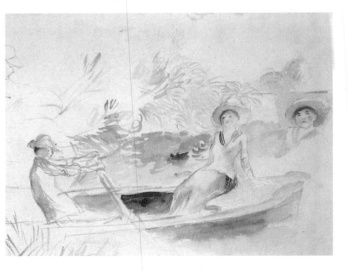

SUITABLE SURROUNDINGS

In this chapter's lesson, we're concentrating on placing our figures in suitable surroundings amid props that will coincide with how these people look to us while at work, while at play. To do this, it is not always necessary to depict the ambience of their environment in a degree of completeness. As artists, we can choose to merely hint at how we want to illustrate their activity, such as the picture, shown below, of the child on the swing. Or the suggestion of a wall in the sketch that appears at the extreme right. How far you want to carry this segment of your picture is entirely up to you.

If the clothing on the figure contains interesting details from the pictorial point of view, these details become an interesting possibility when the artist has to capture the gesture and the attitude of the figure.

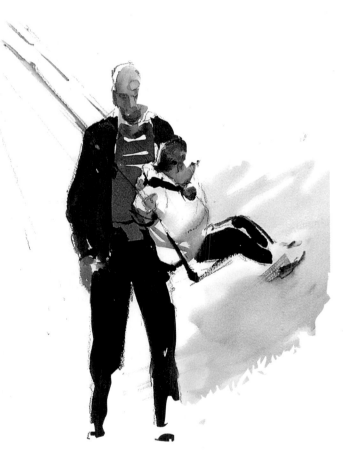

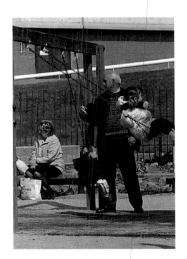

The child in the swing lends interest to this composition. It is a dynamic element; it is the focal point of the sketch. Notice how the adult's face has been changed so he could focus on the child in the swing. All extraneous matter that appears in the photo, seen at right, have been omitted.

The small wall the figures are leaning over is suggested with a line; it is all that's really required as far as detail is concerned.

A BALANCE OF APPEARANCES

One of the most effective ways to attain suggestion in a composition of figures is to leave areas of the picture unfinished; when one or some figures remain outside of the format, cut off by the borders. This technique was used by some Impressionists and their followers, and they had learned it from the Japanese engravings. This unfinishing creates a balance more dynamic and attractive; a balance of appearance more spontaneous and fresh, more inspired.

STEP-BY-STEP

A Figure in Action

Saturday morning at the beach. The sun shines bright and hot and a group of young people has gathered to play a game of soccer on the sand. I took a series of photos of the group. For my step-by-step demonstration, however, I isolated one young woman. I studied her movements, trying to capture certain gestures that repeat themselves when she follows the ball and advances with it between her feet. Once I became familiar with her attitudes, I took my watercolor block and my portable paint box and began to work.

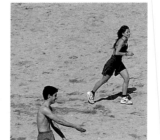

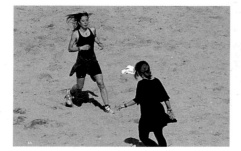

■ THE PROCEDURE

I decide on my approach. For now, I will concern myself only with the effects of light and shadow on the head, the legs and the arms. I establish a strong contrast that comes off the dark outfit. In the drawing you can see the outline of a second figure, running behind the girl; I will not carry it any further. I choose to leave it unpainted to avoid complications to a sketch whose principle interest is the girl in the dark outfit.

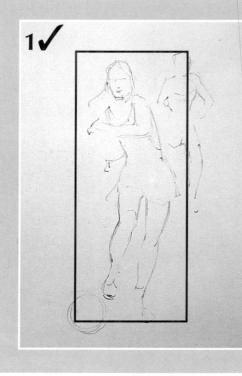

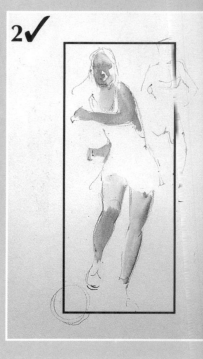

STEP-BY-STEP

1 This drawing is the key to the total progression. The sketch tries to keep the movement and characteristic gesture of the figure. The lines that direct the movement are principally those of the left leg and those of the shoulder, the oval of the head and the right leg. The figure in the background is merely indicated rather than drawn.

2 I start to paint. I always go from bright to dark. First the fleshtones, in which I have used Alizarin Crimson and Cadmium Yellow Medium. The mixture of the two colors give an orangish flesh. But this color alone is visible in the flexed arm; in the rest of the limbs, water clarifies the mixture to the point of setting down the color in the most illuminated zones (the muscle, the interior side of the right calf). There is no room for details.

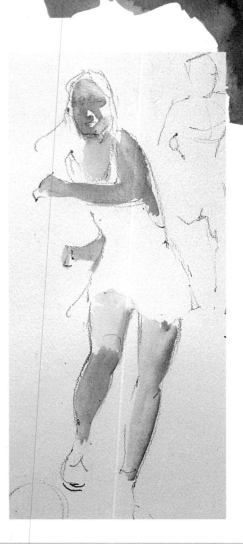

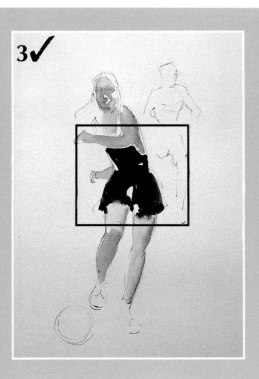

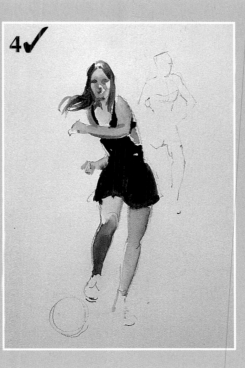

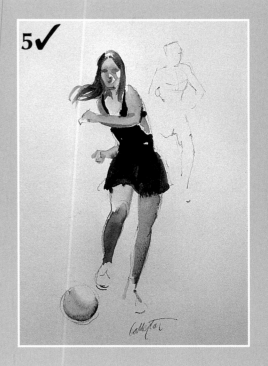

STEP-BY-STEP

3 The blue of the dress is painted rapidly in a uniform color. The blue mixes lightly with the pinks of the still-wet fleshtones. I like a happy accident of color mixing. Unexpected effects like these give freshness to the sketch; you don't have to be afraid of the result.

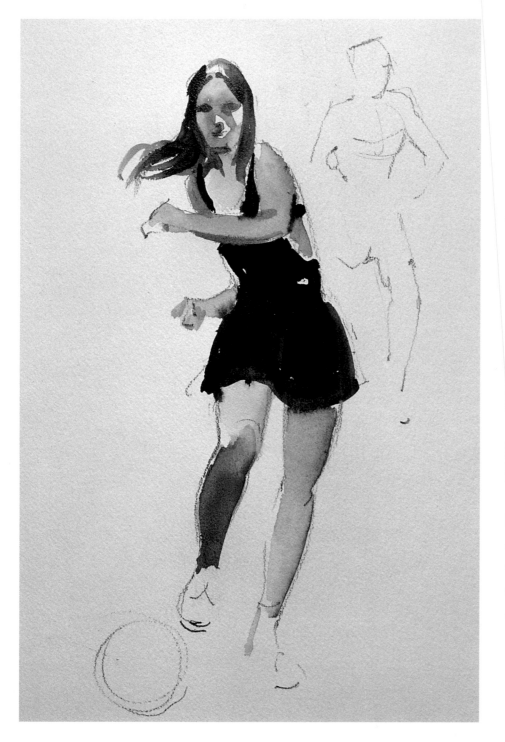

4 Here I have stopped to add some details. In the first place, I have blended and darkened some of the fleshtones, painting over with Burnt Sienna. This addition is especially visible in the calf of her right leg (the one at our left) and thanks to this more intense color, the leg definitely comes forward. Also I took this opportunity to give the head, the hair and the face more definition. I didn't stop myself with strokes in the face because this would make the figure too static. Finally, I painted the folds of the dress and finished outlining the contours.

5 To finish off the sketch, I put some form to the ball, shading lightly its under part with a very light blue. One of the tricks I used to be able to give movement to the figure was not to finish the feet, leaving them a rough sketch, lightly indicated with the lines of the drawing.

STEP-BY-STEP

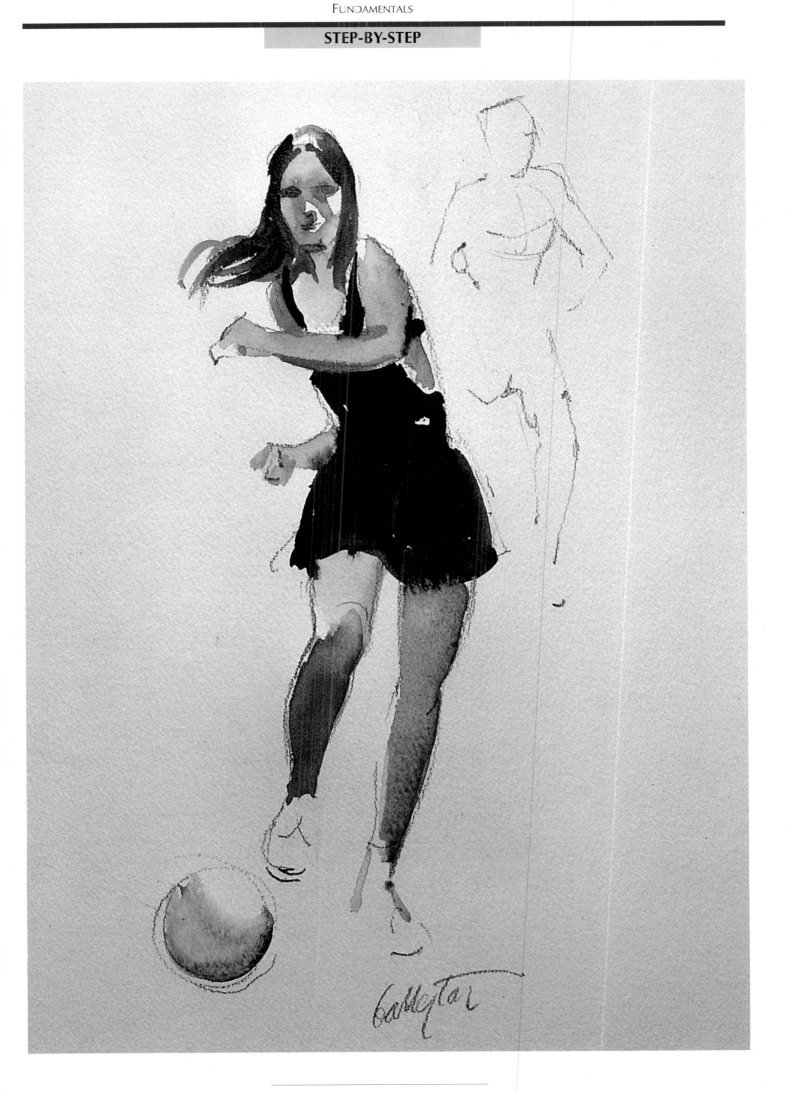

How to Heighten Action

My aim in this step-by-step demonstration, was to intensify the action that my camera captured. This would mean editing my photos to come up with an attitude that says ACTION. For this picture, I used a somewhat limited palette of the following colors: Cadmium Yellow Light, Yellow Ochre, Burnt Umber, Ultramarine Blue, Alizarin Crimson and Lamp Black. The important element in this demonstration is the spirited brushwork that succeeds in separating the painting from the photograph, an ever-present problem when we are forced to use photographic references. I hope you can see, in comparison with the photos, that I have tried strongly to remove any photographic "look" to my interpretation.

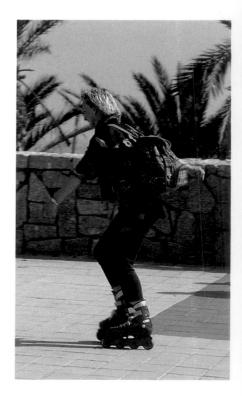

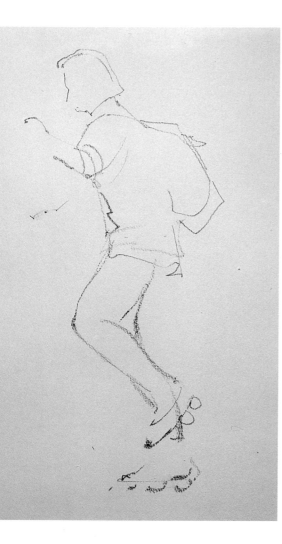

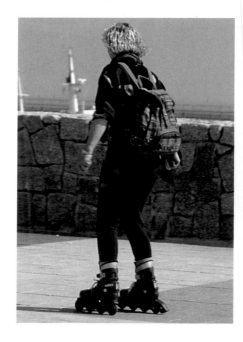

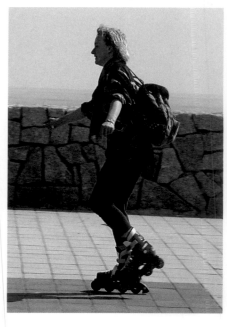

1 The drawing of this figure is more simple than that of the step-by-step of the soccer player. In this demonstration, I have captured the movement, truly like a photographic candid. The stroke is almost continuous: with one or two lines I have outlined completely the perimeter of the figure giving all importance to her left leg which is the key of the action. You'll notice that I used the third photo as my reference, raising the leg a bit more and changing the woman's left arm quite a bit to inject more zip to the action.

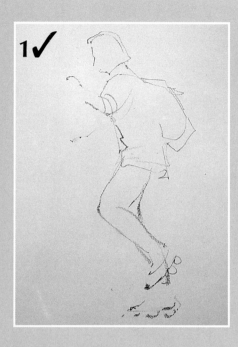

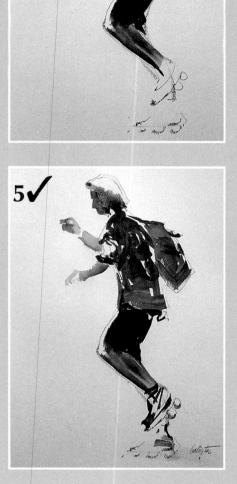

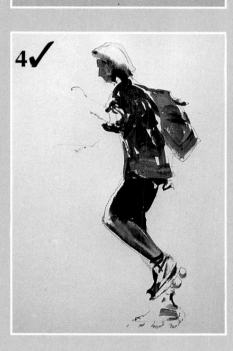

■ THE PROCEDURE

Here is a brief, simple sketch with direct color and with only necessary shading to give validity to the figure. I want to point out the importance in this exercise of the paintbrush that moves the form. These touches are very quick because the speed of the skater's movement doesn't permit delineating small areas; what we get is an impressionistic treatment. My basic intention was to stress speed.

2 It all happens fast. In the time that you read these lines, I have already painted half of the figure. Notice the strokes that construct the body— they are touches of color. Fortunately, there is no time to overwork the head, which I made with Cadmium Yellow Light and a Yellow Ochre applied without mixing, leaving them to gently blend.

STEP-BY-STEP

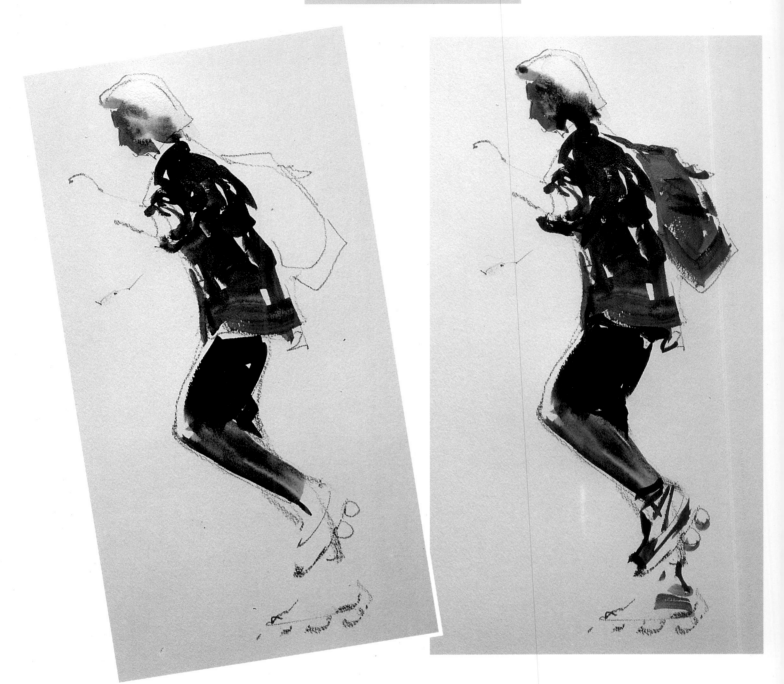

3 To cover all the whites and give vibration to the color, I made small red strokes in the spaces left in the Ultramarine Blue blouse. What is interesting at this moment is how I handled the leotards. It's a black splotch that becomes clearer toward the calf by use of water. The clearness and the direction of the stroke not only define the form but contribute to the dynamics of the movement.

4 I used the same technique to do the blouse. Then, gentle strokes of Yellow Ochre with other earth shades were utilized for the knapsack. Thanks to the fluency of the brush, the body was done in scarcely six brushstrokes.

5 Before finishing the painting, I painted the arms, using the same spontaneous strokes of Cadmium Yellow Light and Yellow Ochre. Working this way, things don't always come out this well because it depends on the element of skill at the moment, and there isn't a second chance.

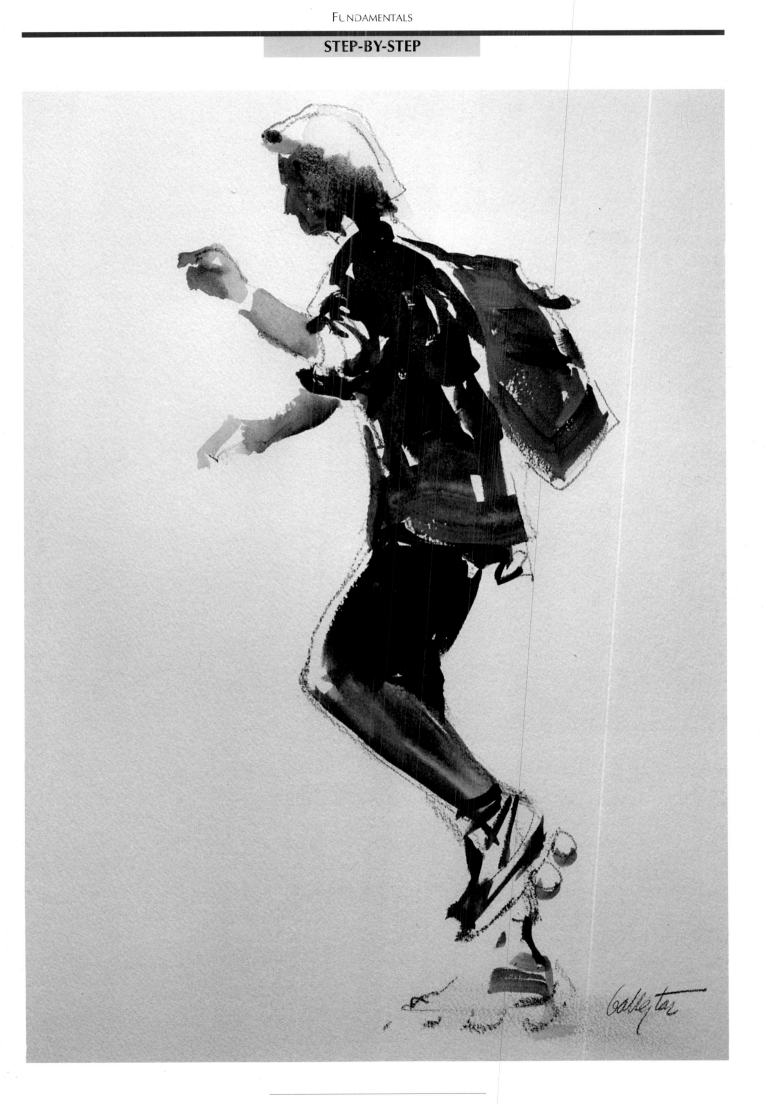

STEP-BY-STEP

Using the White of the Paper

A ttitudes of people define and underline personality, but also they can have a more general value, one that's more universal. For this step-by-step progression we have chosen a posture that's common to many people, part of a human activity—washing one's hair. Degas was a truly great student of this and repeated it in many compositions; to a certain point, this insignificant little genre action became Degas's trademark. We recognize, however, that this motif is a real artistic theme in its own right.

■ HELPFUL HINT

In work like this you can use a good photo or you can work with a model. The modeling sessions can be five to ten minutes at most so as not to tire the model and not to lose the natural-ness and spontaneity of the action.

■ THE PROCEDURE

To show you how important this demonstration is, I have broken it down into ten steps. The bulk of the work is concentrated in the tonal definitions of the flesh of the figure. The watercolor has worked itself into a very restricted chromatic scale composed of siennas, Yellow Ochre, black, blue and yellow, colors selected to bring life to the coldness of the grays. The process is a tight one, based on intensity of tones and looking for the necessary contrasts that give the attitude its pictorial quality.

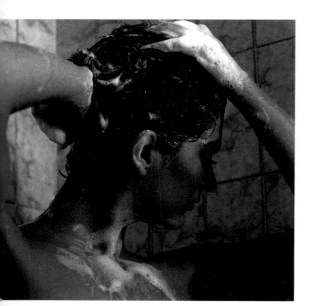

1 To start, I wanted my initial drawing to be complete, detailed, and correctly constructed. The contours were important, those that form the arms presented a fairly complex position, especially the left one; it required a detailed observation to be able to place the hand inside the hair.

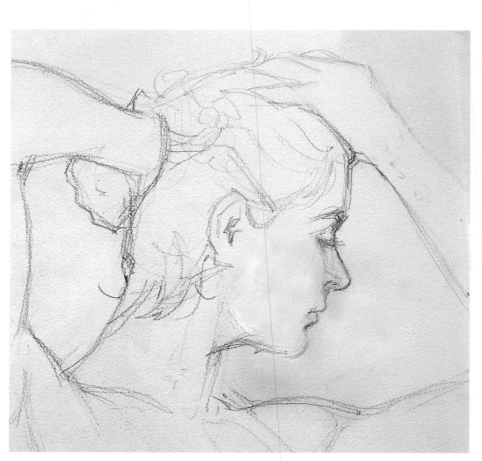

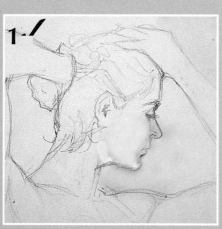

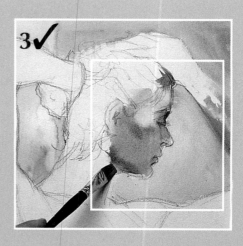

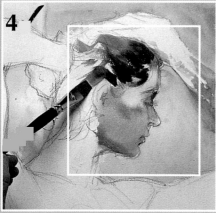

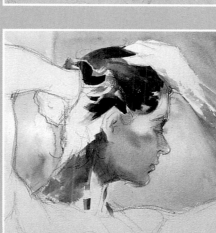

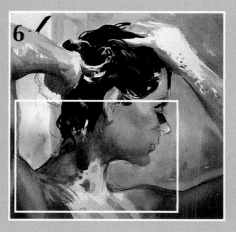

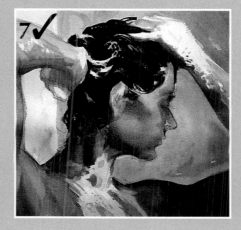

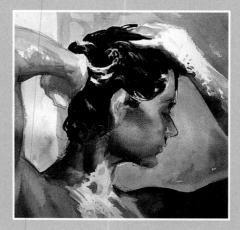

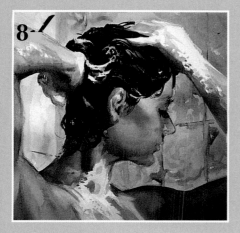

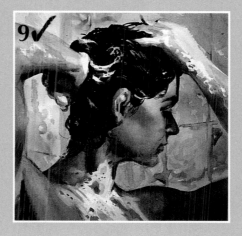

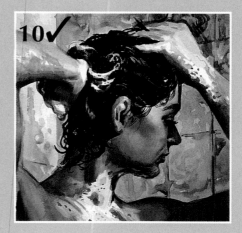

STEP-BY-STEP

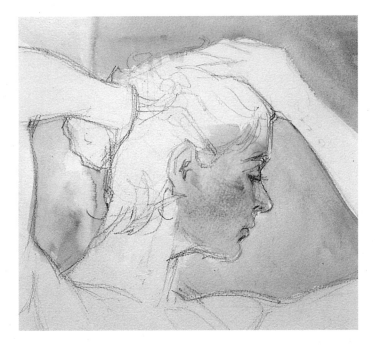

2 The initial wash and the first appearance of the grays will be the basis for the Yellow Ochre that I mixed with a wash of Burnt Sienna for the fleshtones. These grays are two intensities of the same gray, composed from Burnt Sienna and a bit of Ultramarine Blue, the juxtapositions of which serve as the cool color of the shower. The facial tone has a base of Yellow Ochre and Burnt Sienna with a touch of Burnt Sienna to underline the cheekbone.

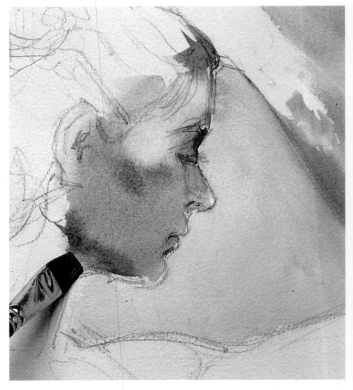

3 The facial fleshtones are more delicate than for the rest of the figure. These tones need a joining of special qualities that give singular character to this painting: the face has evidence of water on it, and also of humidity. I begin to stroke in the shadows under the jaw over the dried flesh color.

4 The hair, which is the main element in this piece, is difficult because the strokes should create wet locks of hair in water and soap. For my first attempt at this effect, I make use of the square form of the lock of hair by painting in the wavy character.

STEP-BY-STEP

5 In this image we see the first work on the arms. Here I have to show the free treatment based in Burnt Sienna dissolved in a lot of water. For the moment it doesn't matter to me to leave my strokes fairly visible; this is the first appearance of form.

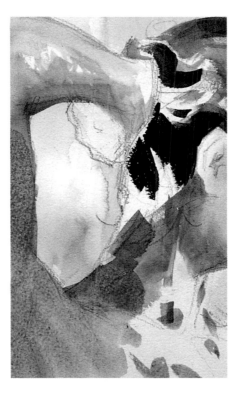

6 In this step, we can already see the beginnings of intensity in the neck. This is a delicate part: it's important to keep the transition from dark to light that starts at the shoulder and goes to the jaw, of the cylindrical form of the neck and not a flat level plane. Another important aspect is the beginning of the painted area that will define the left arm.

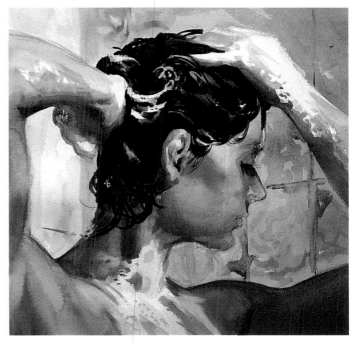

7 At this time, I resolve the transition between the neck and the head. The left arm is represented by emphasizing the most significant shadows. I begin the soapy foam, which is white paper left alone. An area that is almost finished is the hair; I believe I have achieved the image of humidity, an impression that I tried for.

8 Now, I have introduced some important details. In the first place, the tiles on the wall, which are rectangular and covered with a very gentle color; on the other hand the darkness of the right arm that now contributes a definite contrast in the composition. And above all, the blended work of the face: little by little I made gentle transitions through delicate passes of a damp paintbrush over the painted area to get the smooth complexion of the young model.

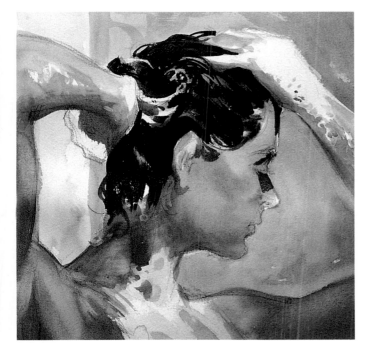

STEP-BY-STEP

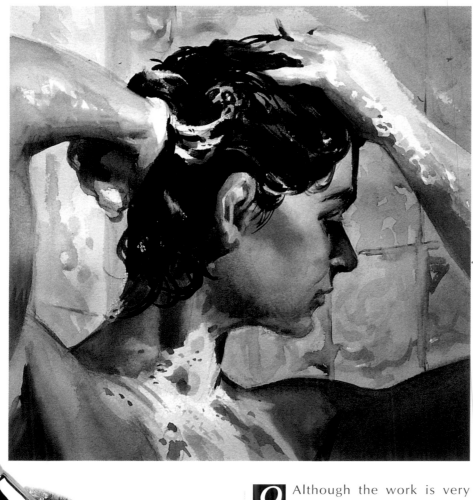

9 Although the work is very advanced, I find motives to continue blending the color. This blending especially favors the enhancing of the whites (the white of the paper) that represent soap suds, which it now looks like. I have finished the eyes. The nose and the mouth I have finished in all their detail, unifying this area of the face with an outline of a very dark shade that, by contrast, gives relief to the cheeks.

10 Here is the finished watercolor. I have added as many details and variations as I have been able. This is one of those pleasing themes of which the artist never tires. This is because of its universal value, by the beautiful gesture, of the elegant movement of the head and arms.

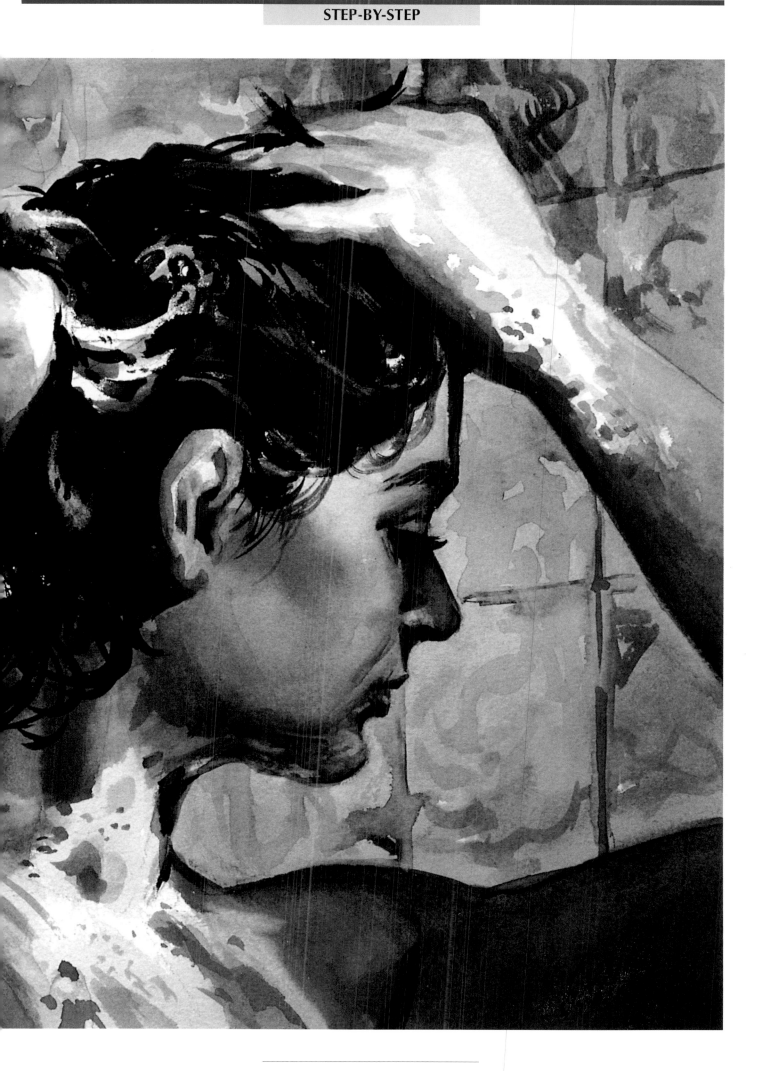

FORM AND CONTENT
How to Depict Character

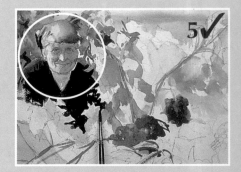

When I took this photograph, the prospect of painting the woman and the scene excited me. Here was an old woman at work in the vineyards, doing what I guessed she had been doing for a great number of years. This painting would be one that was intrinsically linked to a marvelous, heart-warming story. Upon seeing the painting, viewers would be drawn to its provocative drama, wondering about the peasant woman. From a technical standpoint, I was intrigued by the light-and-dark pattern of the scene and fascinated by the many textures and how I would deal with them with my watercolor paints.

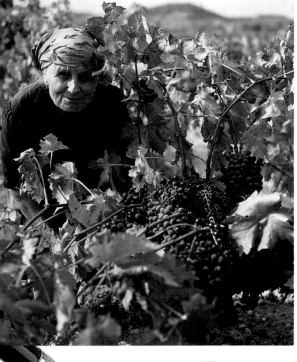

■ HELPFUL HINT

To do a watercolor like this, where details are so important, I felt that I would need a paper of medium texture. I chose, then, a cold pressed sheet of paper instead of the much more textured rough surface. The paper is a 300-pound cold pressed Arches, a company that's been in the business of making paper since 1492.

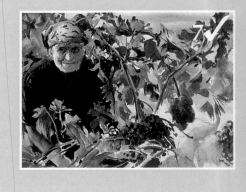

1 For this particular painting, I decided to make my pencil drawing more detailed than I normally would. I made a careful copy of the photograph, anxious to capture the total characterization of the woman. After all, she is the focal point of the piece.

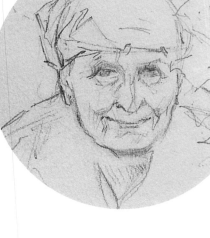

STEP-BY-STEP

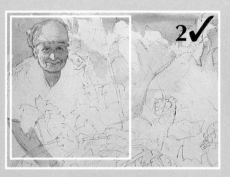

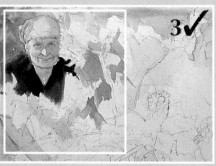

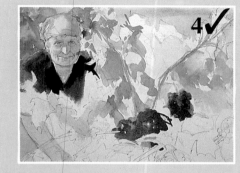

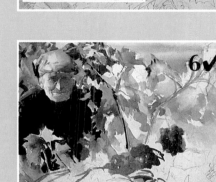

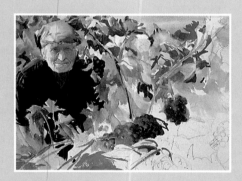

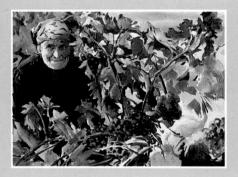

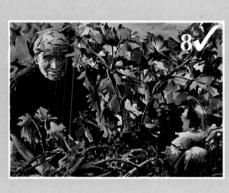

■ *THE PROCEDURE*

In this watercolor the details were important, as much in the leaves as in the face of the woman. Because the wrinkles, the expression and the features of this face are the important factors, I left the vines and the grapes less detailed in my pencil drawing. I knew it would give me more leeway with my brush, once I put it into play.

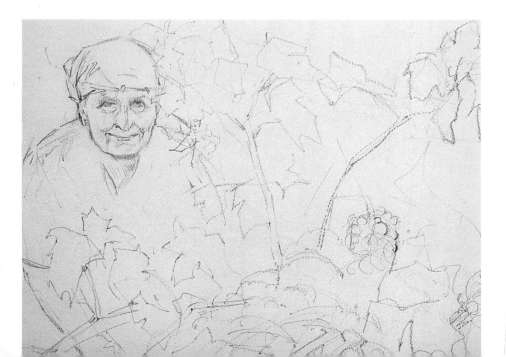

STEP-BY-STEP

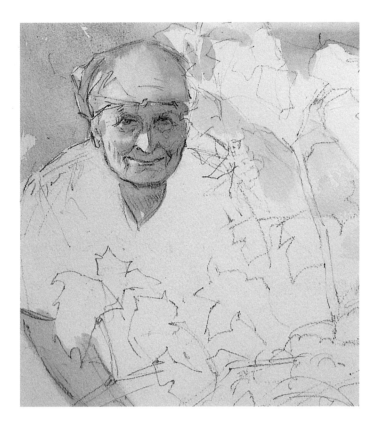

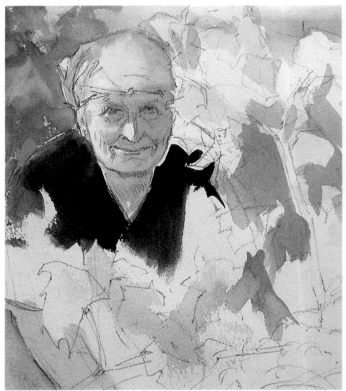

2 The first strokes of color are a mix of Cadmium Yellow Light with Burnt Sienna. I watered this mixture down, because I am only interested in a general base tone for the qualities of light. I made this tone a little more yellow for the figure. The whites of the paper correspond to the brighter lights. I mixed in a little watered-down blue, putting it into the background, and will leave it like that during the entire painting.

3 Over the previously applied yellow tones, I apply some gentle, leafy greens. These are greens that blend with Yellow Ochre to place the yellowy green of the leaves in the background of the composition. Mixing black with a little Ultramarine Blue gives the dark tone to the blouse. Here we should take care, because the contrast of dark and light is very intense. We don't want it to overpower the composition at this point.

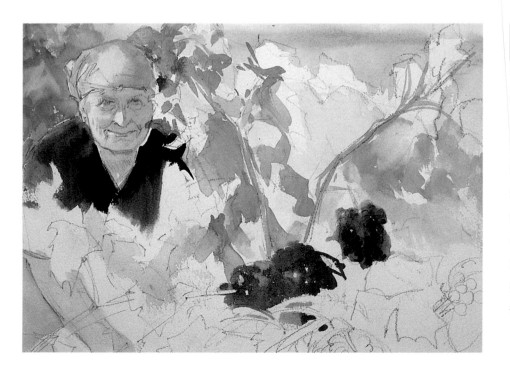

4 Utilizing the yellowy green composed of Sap Green and Yellow Ochre, I paint the leaves thicker than life. It is useless to paint leaf by leaf: the solution is to outline a sufficient number of leaves to give the effect. The more diffused they are the more convincing and realistic they'll be. Also, I paint the bunches with a base of red-violet (mixed from Ultramarine Blue and Alizarin Crimson). Over this base, I will detail the grapes.

STEP-BY-STEP

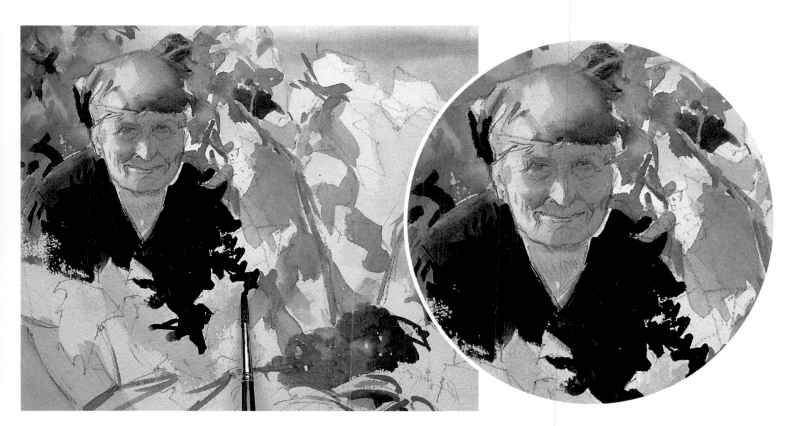

5 The Cadmium Orange strokes correspond to the branches of the grapebunches; they give me a sense of the tangle of forms and colors of the vine. Using a Lamp Black, I paint the darkest part of the blouse, placing a lot of attention on the contours of the leaves. The contrast of dark and light between these leaves and the black will give pictorial strength and clarity to this watercolor, which could run the risk of confusion for the excess of details.

6 In this moment I begin to go into the details of the figure. With subtle work of modeling, the illuminated part of the blouse was repeated in the scarf that covers her head. In the head scarf, I have painted in some creases over the previous gentle modeling. Moreover, I have hidden with Burnt Sienna the part of the face in the shade and prepare myself to begin the face's textured details.

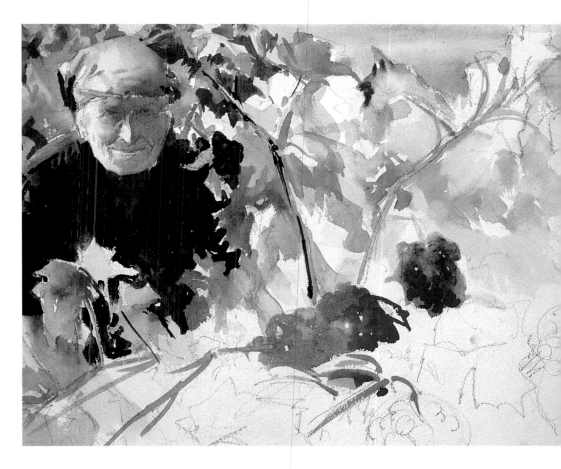

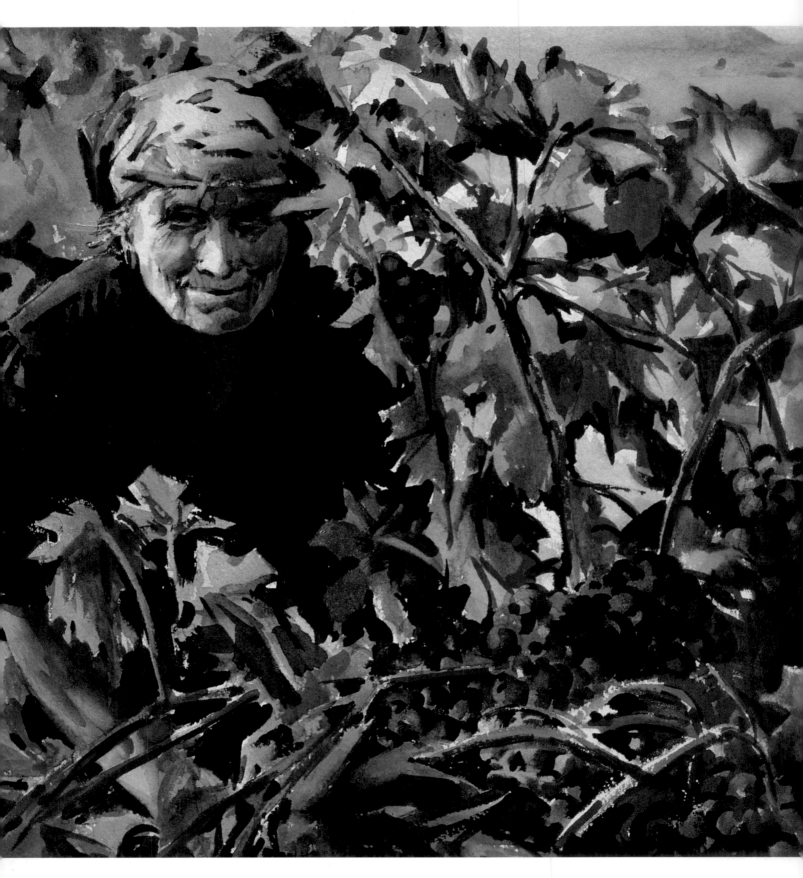

8 The finished watercolor shows a detailed work. I have brought the woman's characterization to the maximum, looking for all the possible mixes in the shadows of the face to help the expression. The old woman possesses a personal expression and I tried to carry this over the grade into the finishing of the leaves and the grapes. I like the strong patterns of light and dark in this painting.

STEP-BY-STEP

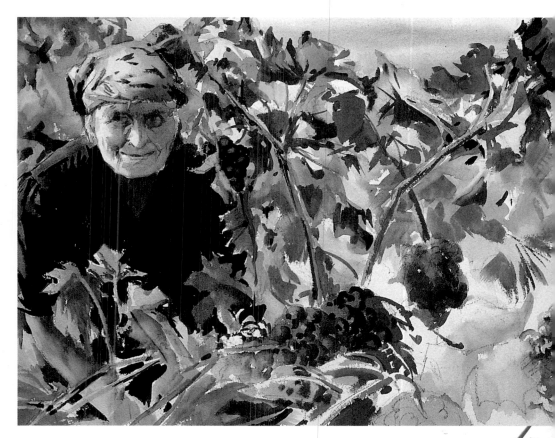

7 In the leaves and the grapes I have used a background looking for lights, shadows and reflections; from the base of greens and Yellow Ochre I have intended to enrich the scale of color to the maximum with dark greens, grays and some yellow. The violet colors of the bunch begin to show the detail of the grapes, a detail based in the darks of the shadows that individualize each of the berries. The details of the face consist in following the most notable wrinkles with fine lines of a toasty color.

The Figure in its Surroundings

This demonstration shows that while we are characterizing a person, the interest centers itself more in the activity and environment that surrounds the figure. I photographed this fisherman at the docks, capturing him unloading his catch. The fisherman possesses an interesting appearance. Not only are his head and expression of great interest but his gesture, attitude and body movement are interesting from the point of a pictorial view. His characterization, for the most part, will dominate, but you will notice that the instruments of his trade, including, of course, the boat's machinery in the background, lend authenticity to who he is and what he does for a livelihood.

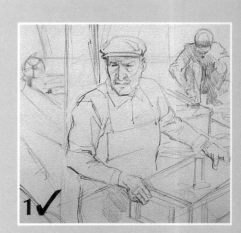

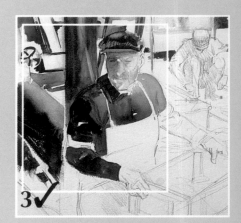

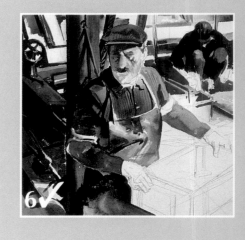

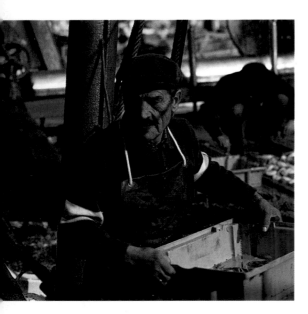

■ HELPFUL HINT

Please notice that I've put checkmarks in all of the steps that I've written about and which appear in larger format on the pages that follow. In this way, you will be aware of the in-between steps for you to study for yourself. I've used this method in all of the step-by-step demonstrations throughout this book.

1 The drawing at the left is a tight duplication of the photograph above it. I have used pencil lines to indicate tones on the background figure, while leaving out small details. What's left is a compositional structure.

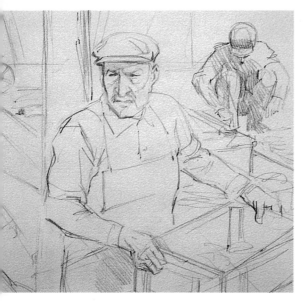

Before any paint was applied, I had to make sure that the elements of the composition would support the progress of the work. The mast, boats, cases, etc., form a rich environment that will be interpreted in planes, tones, lines and color. In this sequence, I have given a methodical treatment to each one of these planes, lifting them out of a potential monotone of forms and colors. My main concern in this drawing was the composition of the central figure.

STEP-BY-STEP

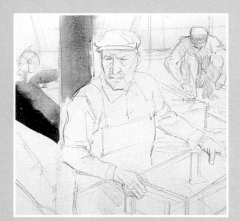

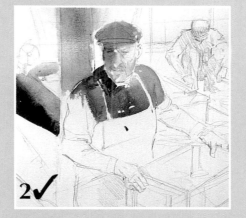

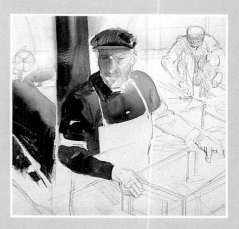

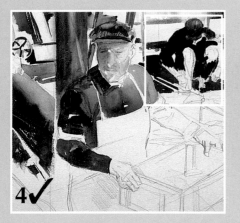

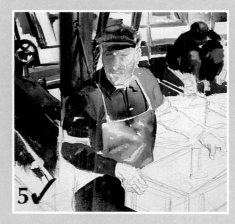

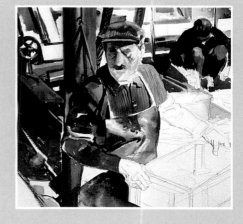

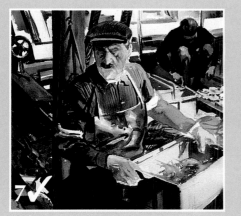

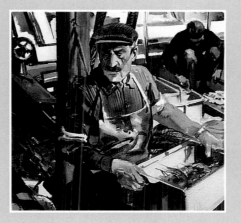

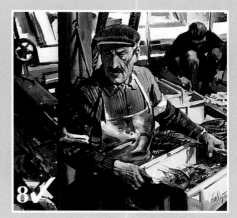

■ *THE PROCESS*

Check the photograph on page 42 and then look at all the steps that are reproduced on this page. Note the changes made in drawing and color in order to inject clarity into the work.

STEP-BY-STEP

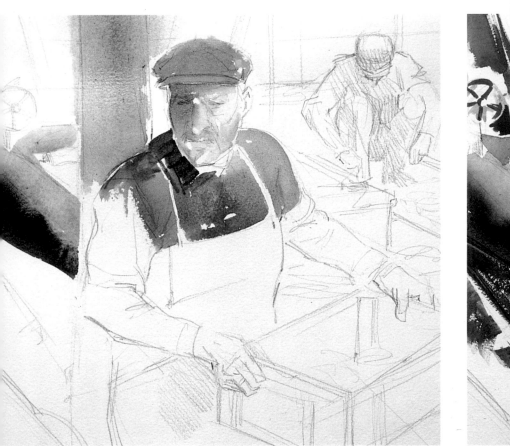

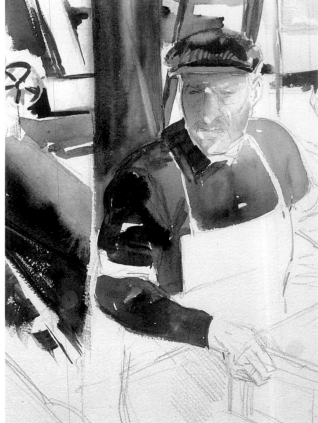

2 I started the sketch with direct color. Choosing the contrasts of yellow, green and black, I achieved more than an approximation of color. These contrasts serve as a guide and also suggested the basic relationship of light and color, how it is valued in the head and the chest of the figure.

3 Having intensified the color originally sketched in, I manage to secure the tone that will be dominant in the watercolor: the mast is now of a richer and darker color, lightly modeled. I also did this to the cap he is wearing; it makes it more interesting. The watercolor moves forward from a base of levels of pure color that wouldn't run into each other. What interested me at this stage was to compare the relationships of color that were created between these planes.

4 Working on the figure in the background, I treated him with blocks of color that I painted in very dark blue and black. These blocks corresponded to the shadows with the blue dominating the middle ground. The procedure that followed these sketches based itself in the arrangement of light and shadow, to the point that the only lights were the white of the paper.

STEP-BY-STEP

5 The most outstanding aspect of this step in the progression is the gray of the fisherman's apron. This gray has a powerful chromatic value that comes from all the colors that surround it. The gray contains a great richness of value that gives volume and flexibility to the figure. For the rest, I worked the lights of the background that before were just the white of the paper.

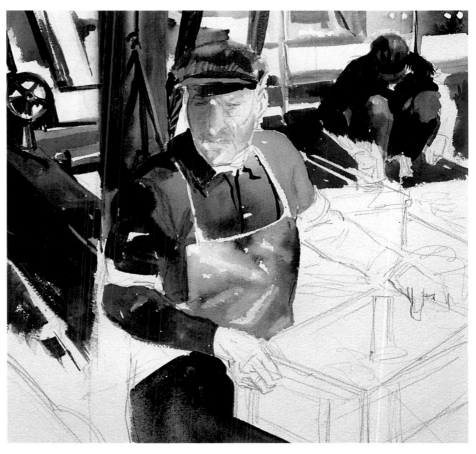

6 Moving along, the painting accepted still more contrasts, and this is the treatment I gave to all the surfaces. I look for any way to intensify to the maximum. This is especially visible in the apron of the fisherman which at this stage possesses a rich plasticity. It also occurs in the head of the figure as in the shade of the cap's visor, which offers an excellent opportunity to re- establish the contrasts. All those contrasts give the composition a tone and character much in accord with the theme.

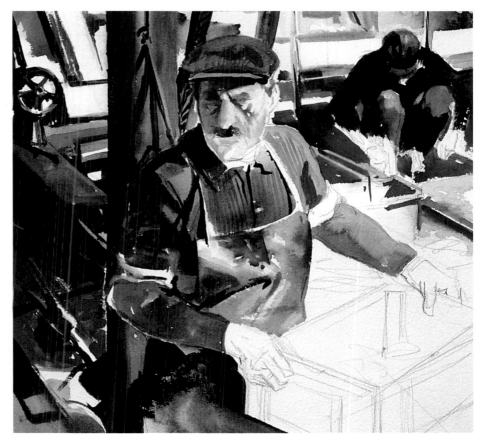

STEP-BY-STEP

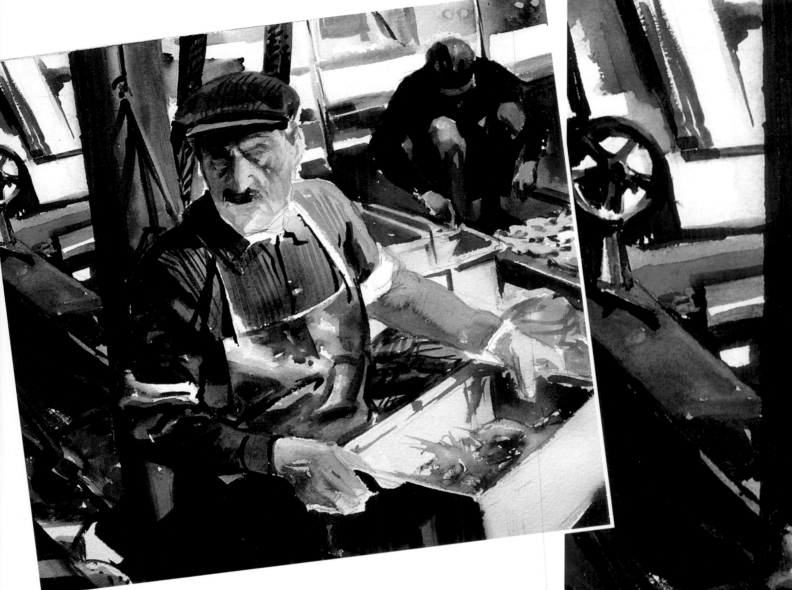

7 Completing the composition with additions of color, more details that were left out of the previous step begin to surface. These details work to join light and vibrant tones in conjunction with dark tones. The fish and prawns are the perfect device for the introduction to the scene of vibrant color. Furthermore, details like the shirt and the major part of the head and the figure are brought out.

8 The painting is brought to a finish with the emphasis on the contrast between the distinct planes of color. Each form itself is fit in without any color and tonal clash. More interesting is the expressive result, the appearance of this figure in its entirety. It is lightly dramatized by the strength and firmness of the color.

STEP-BY-STEP

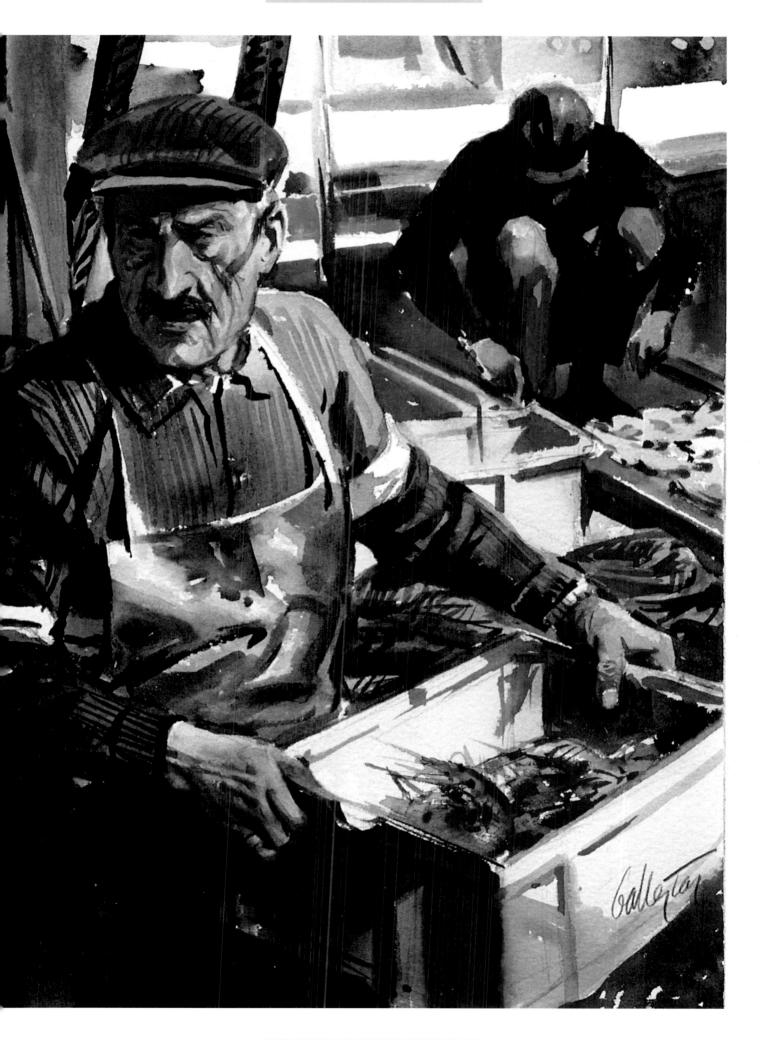

The Sleeping Figure

look at a slice of life that records the human condition in all its honesty can be as riveting to a viewer as a beautiful bouquet of flowers, a breathtaking vista of land or sea, or an exquisitely attractive woman. Throughout the centuries of art, genre paintings abound in their depiction of everyday life. On one of my visits to the big city, I came upon an individual who was fast asleep in the town square. His figure, perfectly at rest, was propped up against the statue in the center of the square. The pose, if you will, was totally spontaneous, free of any of the self consciousness that grips people who are aware of being photographed or even being looked at.

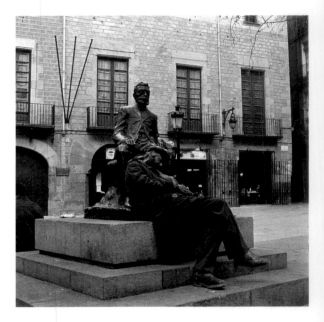

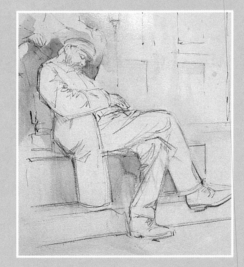

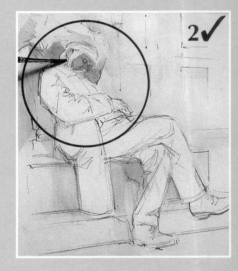

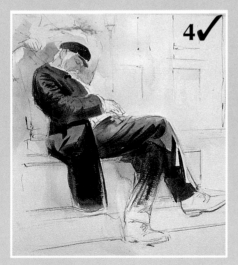

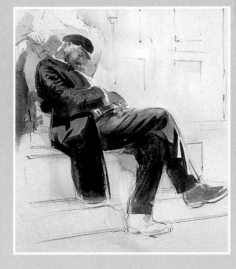

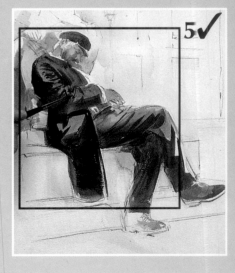

STEP-BY-STEP

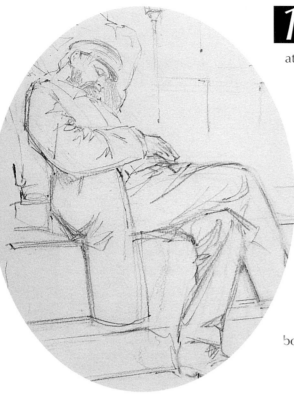

1 The drawing is fundamental to give the gesture. attitude and body movement (or lack of it, in this case) by virtue of the line. This is a line that doesn't occupy itself solely with contour but which sets the theme of the painting by the complexity of wrinkles and creases of the clothes. The drawing also has to define the architectural forms of the statue that supports the body of the subject.

■ *HELPFUL HINT*

At the time of painting the figure of the entire body, it is necessary to pay special attention to the proportions. Making an error in some proportions would show up more here than in a composition that presented only a part of the figure.

■ **THE PROCEDURE**

If one can characterize the process I utilized in this watercolor, it is in the exclusive concentration on the figure. The rest of the watercolor, the whole alley that surrounds the sleeping individual, has been reduced to monochromatic indications. The figure contains sufficient pictorial dominance to justify its presence in the watercolor without other accessories or additions. I chose to reduce the ambience to a minimum so as not to take away from the dramatic impact of the painting.

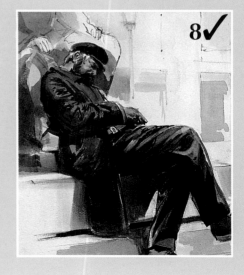

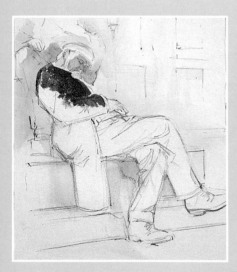

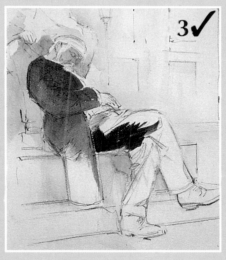
3 ✔

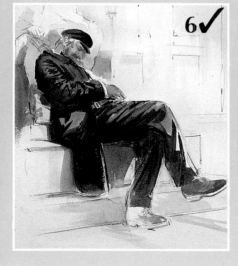
6 ✔

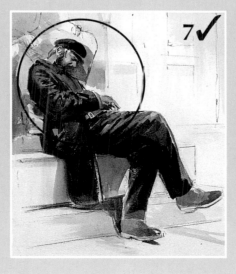
7 ✔

8 ✔

STEP-BY-STEP

2 As I begin to apply color, I use a warm gray, mixed from Yellow Ochre and diluted Burnt Umber to paint the exterior around the figure and give the general tone. The gray will be the background. As you can see, it's a pale tone that functions to frame the contours of the person. Having now surrounded the figure, I paint with a Raw Sienna mixed with Cadmium Orange for the fleshy parts of the face.

3 I have painted the coat with an Ultramarine Blue to which I have added a very small quantity of Rose Madder to make a violet tone in the part of the coat that falls under the arm. I begin to paint the pants with long brushstrokes of black mixed with a bit of Ultramarine Blue. I want you to understand that this first dark sketch won't stay this way. I will extend and cut it down with water to obtain a more diminished and grayish tone

4 We now can see how I am orienting the work of the creases and the wrinkles of the pants and the coat. Although the creases follow a complicated order, the procedure is no secret. Over the dried application of color, I draw the pleats with a pencil point in a tone that's equal to the background, though much darker and saturated. Over these descriptive delineations, I shade the contours with care, for this intensification of the tone picks up the lights, along with the clearest parts of color.

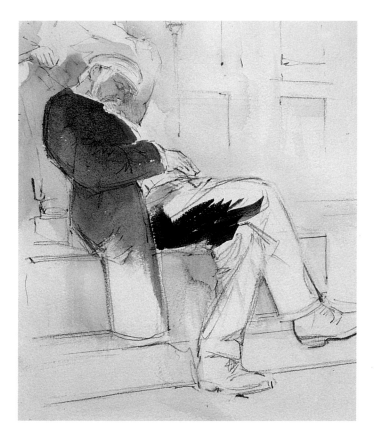

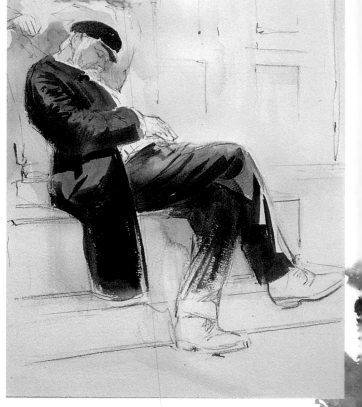

STEP-BY-STEP

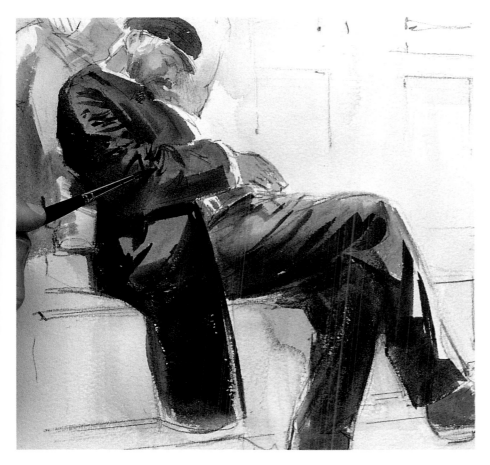

5 I work further on the wrinkles of the clothes. But now there are minor wrinkles, the creases that appear between the strong dark strokes of the more noticeable pleats. I've made them with a small paint-brush going around the fabric, painting over the dark part, which is the most intense blue of the sleeve. This is an essential work of value, consisting of distinct gradual intensities of the same grayish tone.

6 The figure painting is very advanced. Look at what I have achieved with the warm gray of the background — the contrast of this pale color with the dominating blue of the coat create a sober harmony. The pleats are sufficiently worked, all over the coat, so that they now contain a grand rich tone that helps brighten the clean bright tones of the head.

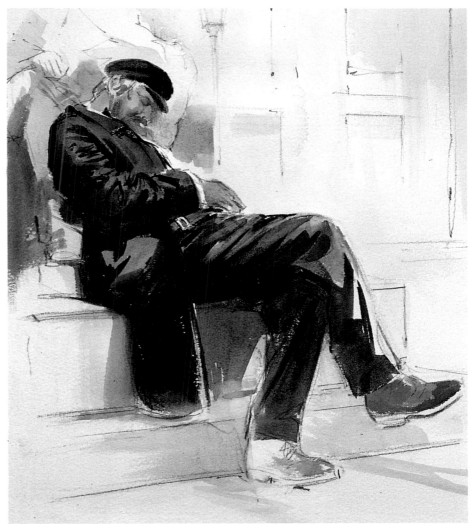

STEP-BY-STEP

7 At this point, I come to the rendering of the background, of the portion of statue against the sleeping figure's leaning shoulder. This results in a base of grays. Here color has no place. All are tonal nuances apart from the pale hint that highlights the fundamental planes of the sculpture. Also, it's worth it to acknowledge the treatment of the pants, more simple and direct than that of the coat but equally positioned toward the heightened bulk of the pleats.

8 I believe that in the finished painting we can appreciate what my pictorial intentions were. I placed maximum interest in the head and body of the figure. A secondary treatment of the background, that I represented in grays, leaves sufficient completion to the statue but never takes away from the sleeping figure. It was the human presence of the figure that interested me. I rendered him with simplicity.

52

STEP-BY-STEP

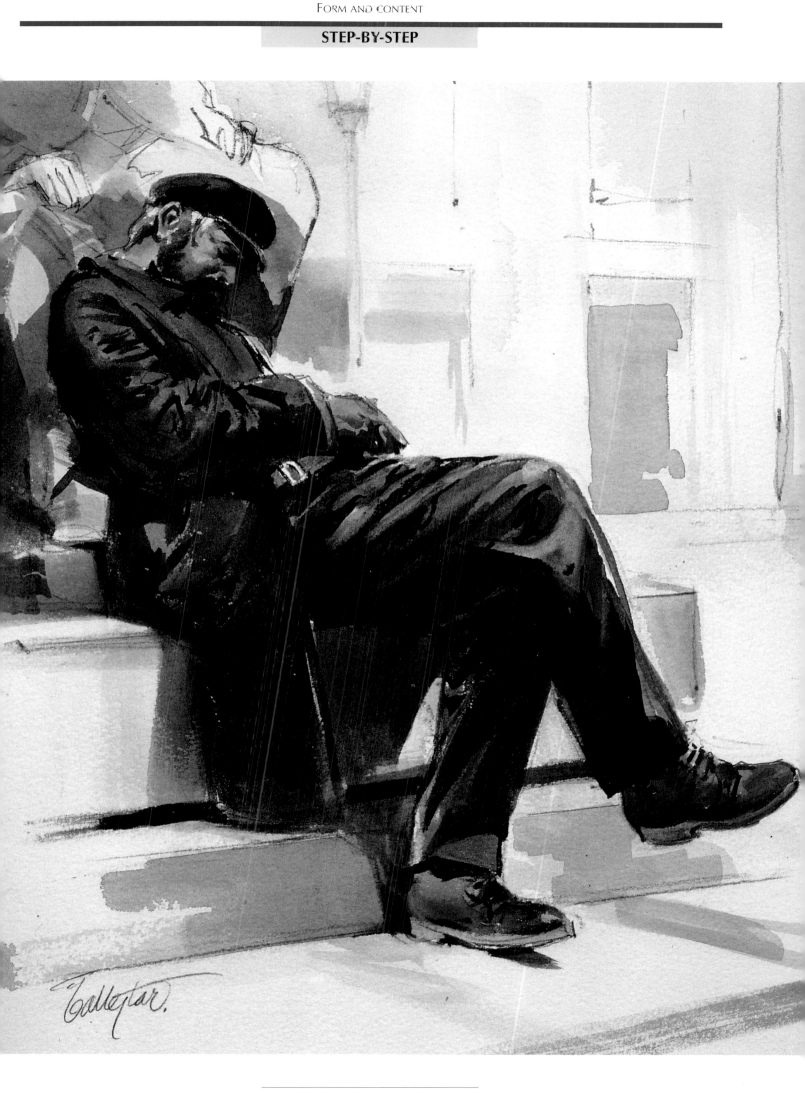

PICTORIAL QUALITIES
The Solitary Figure

H ere's an apparently simple demonstration, that of a young woman at a public telephone booth. What makes this demonstration look so simple to do is my use of a limited palette. Believe me, it's not as easy as it looks. This demonstration is an example of how it's possible to give the appearance of more colors without actually using them. Moreover, I painted this figure with only a couple of tones. It is possible that you may see this as the most simple watercolor in the book. If you think this way, search for the complexities that put the lie to your conclusions. What is interesting in this watercolor, you will discover, is the elegance of the profile and the subtle capturing of the gestures of the figure; they attribute to the combination of an attractive theme with a favorable pictorial rendition.

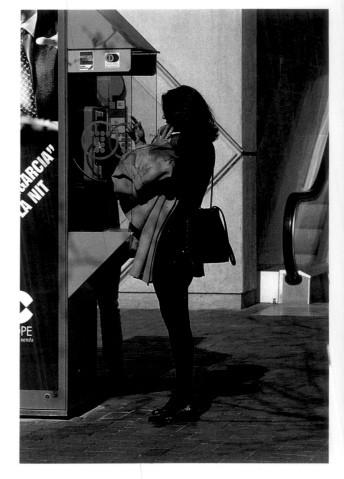

■ HELPFUL HINT

Working with very few colors will force you to use them wisely. This is an example of how to get color with little investment from the bank of colors on your palette.

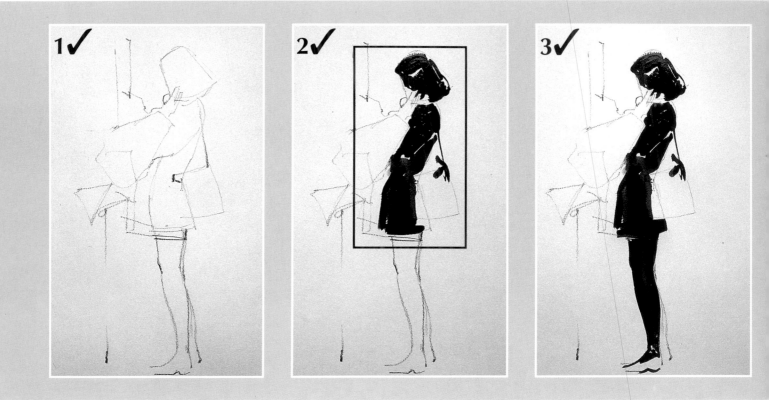

STEP-BY-STEP

■ *THE PROCEDURE*

Though this watercolor may look simple, at the same time it has all of the elements the others have—form, color and a style of utilizing the necessary components of watercolor. The elegance of the profile and the gesture of the figure is interesting in this painting, thanks to the happy combination of an attractive theme and a favorable artistic accomplishment.

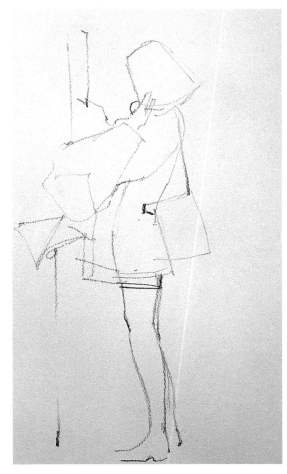

1 The key in this demonstration is the drawing. Through the use of many small lines, I have succeeded in defining the figure and explaining it with elegance, with an interesting rhythm that has suggested to me a simple pictorial treatment. The drawing already possesses its own value, a harmony that I must respect.

2 Black, red and blue. These are the colors that predominate in this sketch. The red and the blue timidly appear in the hair and the skirt, in the rest they contribute by giving warmth to the black. The form of the sketch conserves the elegance that was present in the drawing which gives form to the body without the necessity of working the shading or the creases. All is there, the eye is capable of tying it together.

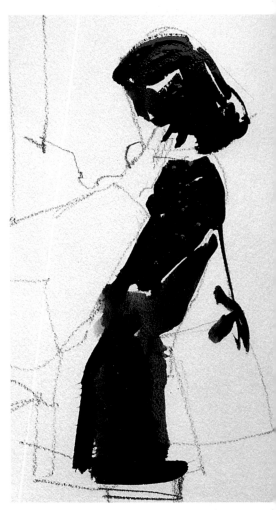

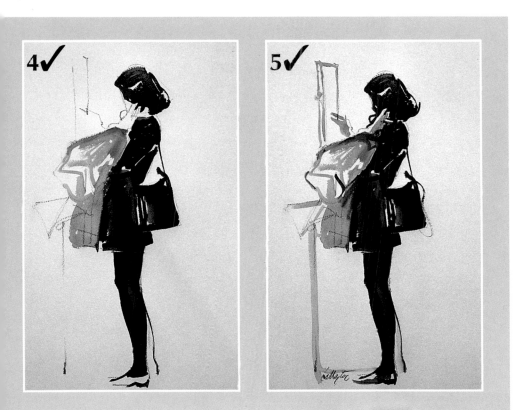

4 ✔

5 ✔

STEP-BY-STEP

4 Trying hard not to touch anything that I sketched before, I apply the violet that represents the coat. It is not necessary for me to study the creases and shadows, the figure possesses sufficient visual strength to naturally accept an approximate sketch and convert it into an acceptable realistic representation. The same goes for the purse; the modeling is no more than the nearly accidental reducing of tone, and there is enough tonal difference for the eye to understand that this feminine accessory is made of leather.

3 Following with the tones that I have established, I extend the sketch downwards, painting the leg of the figure. The sketch level gives form to the figure, from the thigh to the ankle, extending itself to the foot. The bulk is given by the light gradation of red which runs down the leg and expresses the subdued brilliance of the stocking; I feel especially proud of this effect because of its subtlety and simplicity.

5 The space in which the figure is inserted can be perfectly explained between some lines that give us to understand the presence of the telephone booth. It doesn't have to explain that this young woman is calling on the phone. You see it. What you don't see is whether or not she is an attractive woman. From the elegant handling of her figure, however, we know she is attractive.

STEP-BY-STEP

Using Backlighting

Here, in this progression, we are faced with a lighting condition that we have not as yet run into. This is lighting that's somewhat unusual but very interesting. When using normal backlighting, the strong luminosity of the background leaves the major part of the figure half lit. In this case, the subject was photographed in front of a dark screen, resulting in the details and values of the less lit part of the body being perfectly seen. The figure is a street photographer who can be found in places that attract tourists. His old camera is a type that today we see as a romantic memory of the past.

■ HELPFUL HINT
When you backlight a subject, as this one is lit, use gray to mix into all your colors. This helps along the impression that the light is coming from behind.

■ THE PROCEDURE
The photographic sequence presents the problem of how to represent convincingly the backlighting. The most difficult part of the process is how to paint a silhouette with a black background. Although the background contrasts vary, once I got the correct values and essential tones of the figure, the work oriented itself well.

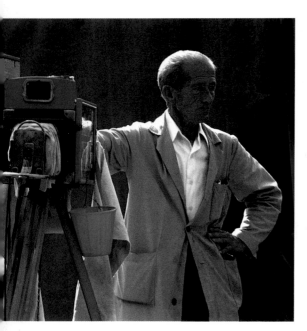

1 As I plan to paint this picture, I see that it's going to be a long and laborious production. I opt for a very complete drawing, which deals with the figure as if we are dealing with a portrait: Not only am I concerned with the expression in facial features but the hair and many lines in the face as well. The jacket and the clothing in general are also drawn with care and detail.

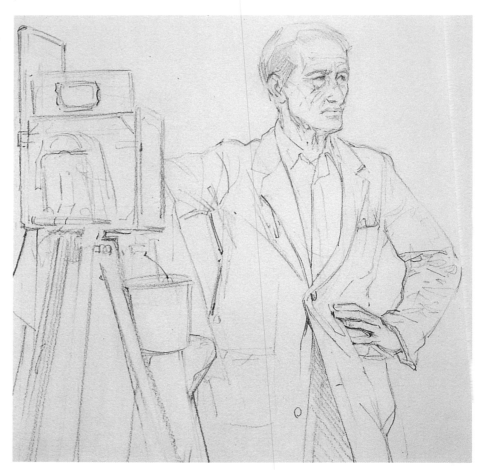

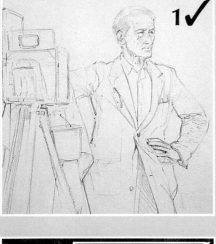

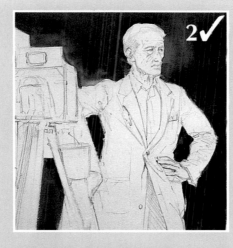

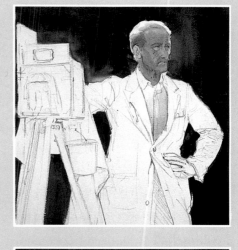

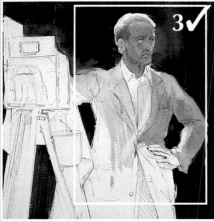

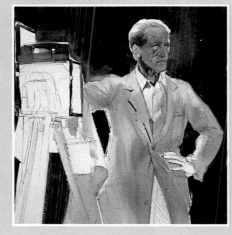

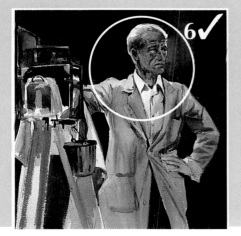

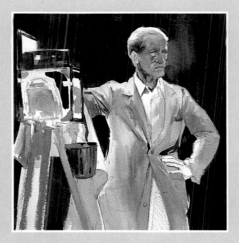

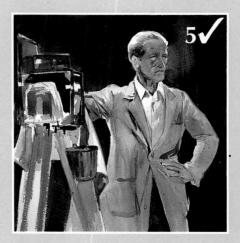

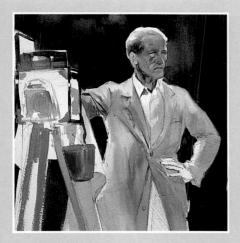

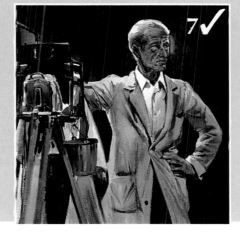

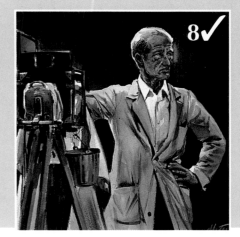

STEP-BY-STEP

2 Strictly respecting the contours of the figure, I paint the background in a blue mixed with black—a gray color—very dark but a bit defined because I am not interested in an intense tone conditioning the color I am going to use for the figure. These colors will not be very intense (except in some details) because, to be so, it will not be a backlit composition, but one that's merely dark and light (chiaroscuro).

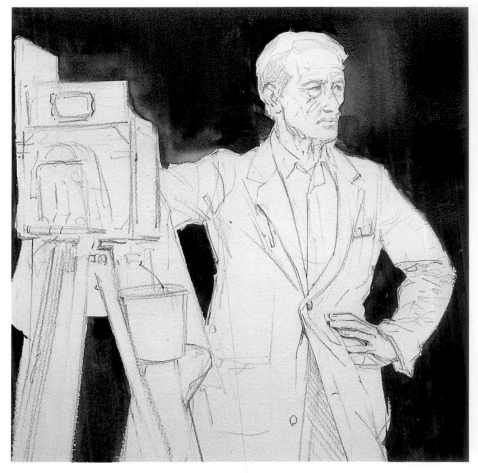

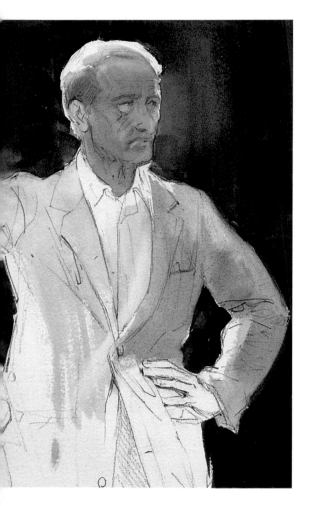

3 As I begin to paint the head of the figure (at left), the flesh-tones of the face are an orange tone, dark enough, although not as dark as in the photo on page 58. This medium tone serves me to develop the first phases of the work. Accordingly, I intensify the shadows. It is important not to lose or confuse the lines of the drawing because I will need them as a guide for working the face in detail.

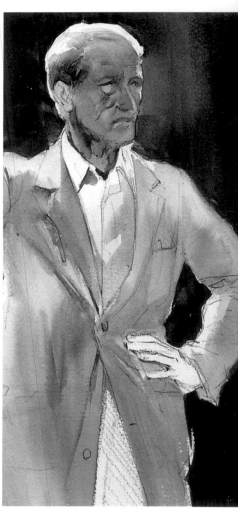

4 Although the muted colors begin to appear, the dominant coloration of the work leans toward the gray, a very dark background gray, and much lighter and warmer in the figure. We can see one of the keys to painting backlit figures: the contours of the head and shoulders are very clear, almost using the white of the paper itself. The contrast between those contours and the rest of the figure will create the luminous look.

STEP-BY-STEP

5 The tonal treatment and light modeling of the figure contrasts with the blocks of strong color in the camera. It is good to realize contrasts of this type for the watercolor not to fall into the application of a formula. Nevertheless, the general gray tone is now animated with reds, blacks, greens and blues, all reunited in the area of the camera.

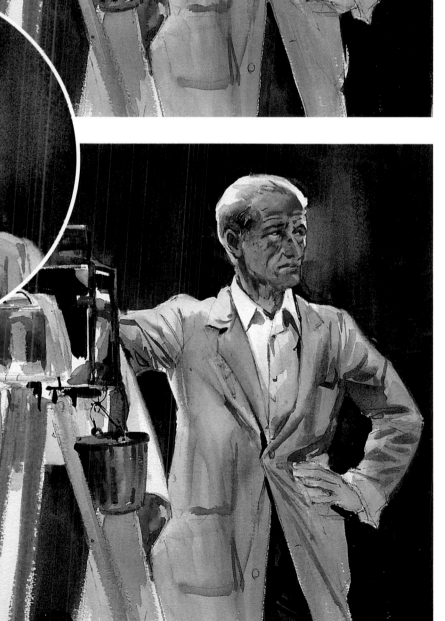

6 Concentrating on the head and facial features, there is definition in the face now. The accumulation of modeling and shadows (skin, neck, cheekbones, temples, etc.) is enough to obscure the face. Had I used a darker base color in all the details, it would have blackened the head.

STEP-BY-STEP

7 I have unified, through shading, the loose blocks of color. Now they compose a more realistic joining and are more in harmony with the level of finishing that I painted in the figure. Another interesting point is the transition from the white of the paper to the color we see in the head and shoulders.

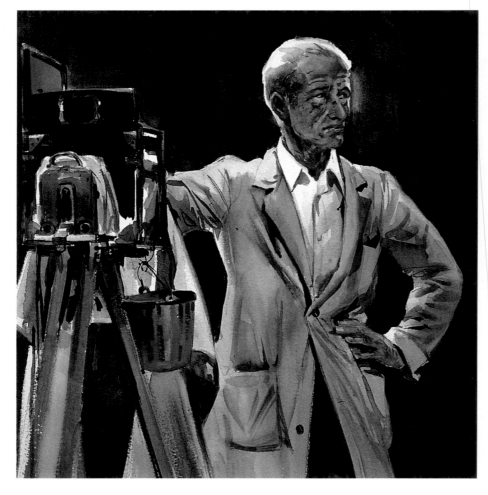

8 In finishing the figure I have been meticulous in important parts like the hands, the head and the camera. The strong contrast between the figure and the background is in a very dark area, more than we saw in the beginning of the painting process. This demonstrates that in the effect of intense light it is necessary to establish the relationships of color and never to literally imitate the natural, for in the natural these have an entirely different effect.

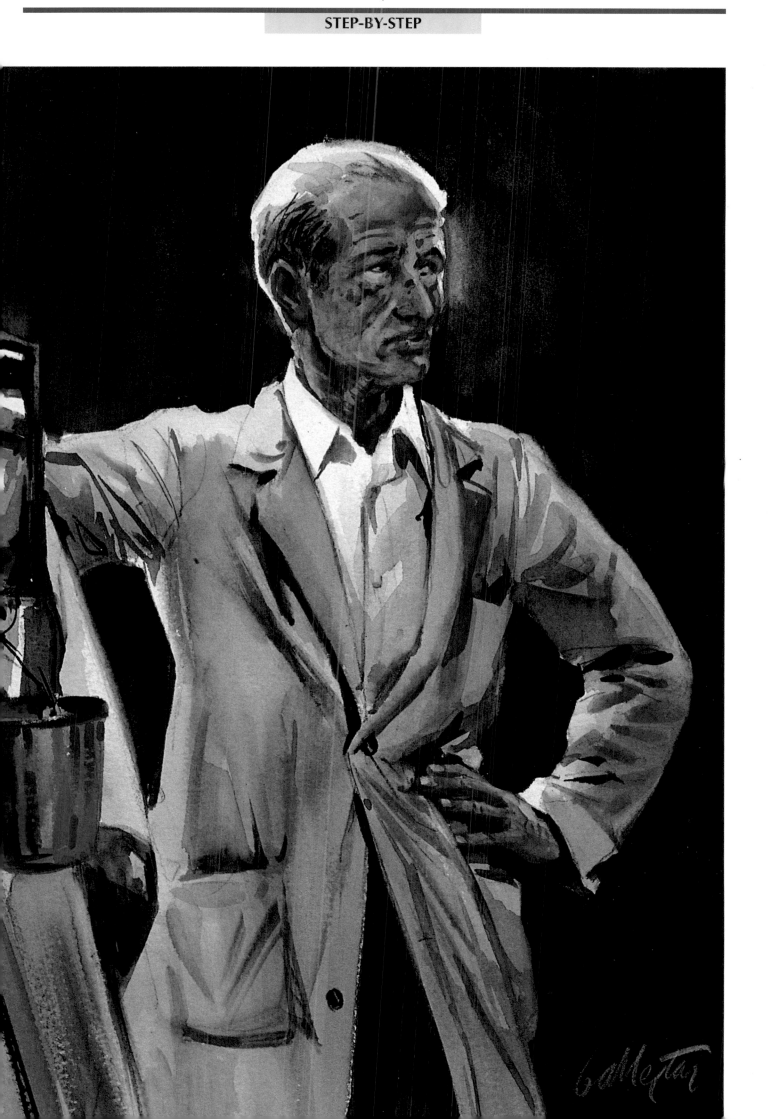

THE THEME OR MOTIF

The Beauty of the Female Figure

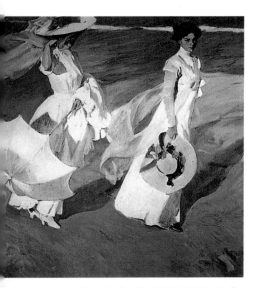

Joaquin Sorolla (1863-1923), Stroll Through the Waves of the Sea, oil on canvas. Sorolla Museum, Madrid. The charm of the theme is intensified by the color and the harmonies that were built upon the lines of the drawing.

FORM AND CONTENT

In the formal sense, passion is something intrinsic to the work of a painter, whatever the theme may be, even when that theme is an arrangement of abstract forms. The way the color is chosen, the harmony of the tones and the quality of the pictorial material are factors that can be a visual delight. This passion shows in distinct degrees in different painters and is a mark of personal style. A highly artistic style will add passion to any motive that the artist develops: the paintings of Rubens, for example, manifest themselves in the isolated objects of a composition or in landscapes, figures or nudes. In figure painting, the painter makes use of gentle, harmonious lines and rich color qualities to develop fully these qualities in the treatment of the figure.

The impact of the line happens at times by its accidental distortion from the academic point of view. The illustration at left shows how the artist used it to advantage.

Frantisek Kupka (1871-1957), Carmin # 1, oil on canvas. National Museum of Modern Art, Paris. The attitude and the gesture of the figure, shown at right, implies a certain kind of beauty that is underlined and reinforced by a powerful chromatic arrangement.

Joaquin Sorolla (1863-1923), The Two Sisters, oil on canvas. The Art Institute of Chicago. The beauty of the light, of the sea, of children's games, of summer pastimes. Ideal motifs for the figure painter who is caught up in his inspiration.

THE HUMAN FIGURE

The motif that traditionally has bound the sensual style of artists has been the feminine figure. Feminine forms have been interpreted, recreated, and idealized by painters throughout the centuries. Throughout the history of art there are exquisite renditions of the male form. From ancient Greece to the contemporary painters, there is an abundance of paintings and sculptures of masculine figures. In the male anatomy, artists have found motifs of infinite possibilities for the student and for the benefit of art lovers. It's interesting to note that in painting babies, the artists of the past, mostly in pre- and early Renaissance, painted them to looked more like small adults instead of the cuddly babies we're accustomed to seeing on baby food jars. Perhaps the reason for this was the difficulty in getting a baby to sit still long enough to pose. Artists had to rely on memory to interpret a baby's face and thus fell far short of capturing the correct proportions. Of course, Michaelangelo, Raphael, and other giants of the Renaissance, represented babies beautifully. But how many Michaelangelos and Raphaels are there? Today, the problem of getting babies to sit still is the same as it has always been—fortunately, we have the use of photography.

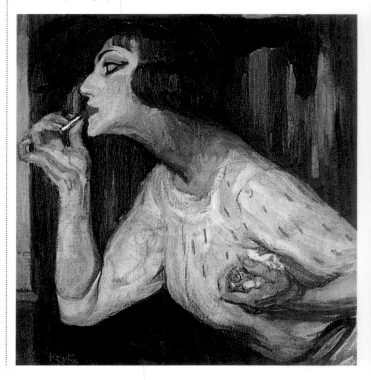

THE VALUE OF NUDES FOR STUDY AND MOTIF

When we consider that a vital part of the anatomical training for many of the revered Old Masters was to be present at, and even take part in, the dissection of cadavers, we can appreciate their great knowledge of human anatomy. We all have to agree that the study of anatomy is much more pleasurable today. The use of nude figures has been invaluable for artists for centuries. It's obvious that as students, artists have recognized the necessity of drawing and painting from nudes as a trusty aid to nurturing their acquaintance with the human form, in every position, in every attitude.

As you well know, however, nudes in art not only function as a learning tool, world-wide museums teem with paintings of nudes that have been done by the many artists who have utilized nude figures in large compositions or even as motifs for smaller paint-

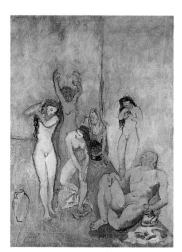

ings. The nude appears in works from every school of painting. And sketches of nudes by artists through the ages have provided museum goers with much to gain from studying them.

On these pages, and others in this book, you will see illustrations by artists who have used nude figures as focal elements in their paintings, be they in the realistic vein or as more contemporary, stylized motifs.

Pablo Picasso (1881-1973), The Harem, gouache on paper. Cleveland Museum of Art. This theme has an imaginative inspiration. Full of melancholy, it is typical of the red era of the artist's long career.

Watercolor permits a special treatment of the fleshtones of a nude figure. The light on the skin can be represented with an extraordinary richness of mixes and of contrasts.

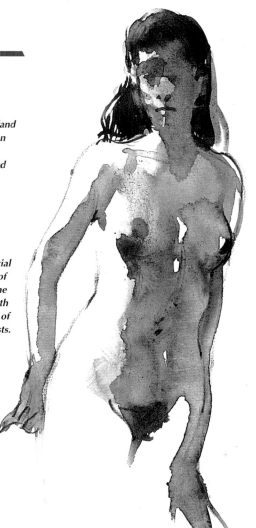

THE SURROUNDINGS

Your impression of the figure should carry throughout the whole work, not just the human forms but also objects and countryside. This accommodation between the figure or figures and the environment should be done with the same creative spirit as the fullness of the painting with the fundamental theme. In this way we can speak also of the anatomy of the countryside or of the objects that by their likeness combine to accommodate the figure.

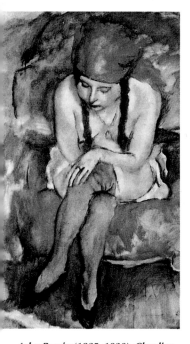

Jules Pascin (1885–1930), Claudine Resting, oil on canvas. The Art Institute of Chicago. In this work it is easy to see how the emotion of sensuality dominates the painting. The forms of the furniture and the soft tones of color that surround the figure work together to heighten the provocative impact of the figure itself.

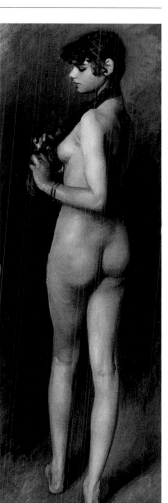

John Singer Sargent (1856-1925), Egyptian Nude, oil on canvas. The Art Institute of Chicago. This sensuous figure represented a wide departure from Sargent's portrayal of Europe's rich people, portraits for which he became famous. He painted the young woman, shown here, while on a trip to Egypt.

Jules Pascin (1885–1930), Sunday, watercolor on paper. Bellier Collection, Paris. The figures in this painting are reminiscent of another French painting of people in a park on Sunday, Georges Seurat's pointillist masterpiece, Sunday Afternoon on the Island of La Grande Jatte.

The Factor of Sensuality

SENSUAL ATTITUDES OF FEMALE NUDES

In the previous pages we saw how the figure has been treated by many painters in many styles as subject matter in sketches and paintings. By using the human form as themes for major paintings, artists have interpreted the figure as subjects and placed them in interesting surroundings, having them do a variety of things. The results, as you have witnessed in so many paintings in museums, have been sound and valid. And, of course, the civilized world is blessed to have the greatest masterpiece of all, Michaelangelo's ceiling at the Vatican's Sistine Chapel, the quintessential graphic representation of the universe and mankind.

These pages contain several illustrations of female nudes in suggestive, sensuous attitudes. There is no denying that a factor of sensuality is prevalent in all paintings of nude figures. It is expected. The degree and taste of sensuality, however, is dictated by the manner in which nudes are presented by the painter.

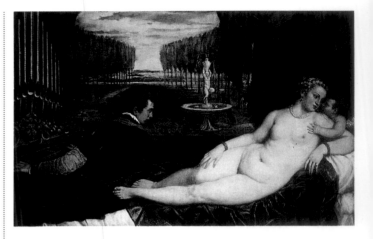

Titian (1477-1576), Venus and Music, oil on canvas. Museum of the Prado, Madrid. A classical example of a sensuous theme, whose emotion is elevated to the highest levels as a result of its artistic quality.

To make the sensuous theme an artistically interesting one, the artist should be sincere in treating his subject tastefully. In the sketch shown above, the fluidity of the pen lines expresses an implication of sensuality.

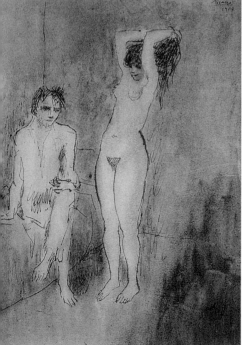

Pablo Picasso (1881-1973), Saltimbanquis, watercolor on paper. Private collection. Picasso has been one of the painters that has treated the theme of sensuality—even eroticism—many times. The versions of the theme incorporate many distinct states of spirit in the different stages of the artist's career. In Picasso's red era (during which he produced this work), the look he painted was melancholy and somber.

SENSUALISM IN CLASSIC PAINTING

While there are paintings by Old Masters in art museums throughout the world that may be explicit on the subject of sensualism, they pale greatly when compared to the works of the artists of the twentieth century.

The example we see here of Titian's Venus and Music, while unconventional in Titian's time, depicts a young, fully clothed male in the company of a very nude Venus. He is occupying himself, and her, with nothing more than providing some musical diversion for this voluptuous maiden. The young man is an entertainer making a house call. The presence of a supposedly virile male in the same room with a nude woman, however, makes this scene an erotic one even though, as stated earlier, nothing sexual is taking place.

By comparison, the other reproductions on these two pages, all painted by 20th-century artists, contain explicit pictures of nudes that may cater to prurient passions.

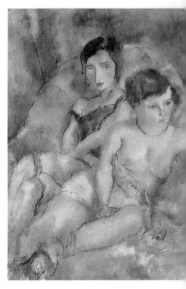

Jules Pascin (1885–1930), Seated Women, oil on canvas. Private collection. The eroticism of this work is a painting of a brothel, elegant and tasteful. In this interpretation, the artist reveals a sympathy for his models, much to the chagrin of Parisian society of his time.

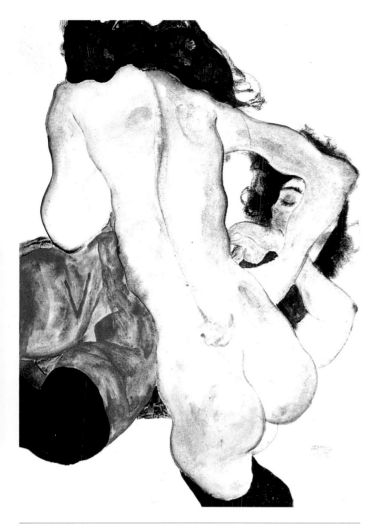

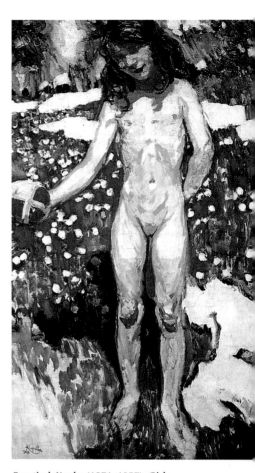

Egon Schielle (1890-1918), Two Woman, watercolor on paper. Private collection. While Schielle scandalized the public of his time with very explicit scenes of his sexual point of view, no one can deny how beautifully he painted the human figure.

EROTICISM AND MODERN PAINTING

The final years of the 19th century and the first of the 20th century were cold to the erotic theme. Symbolic romanticism, modernism and, in general, all the aesthetic movements encouraged expression to the point of extravagance. Urban life was the grand moment of the cabaret, of the brothels of Toulouse-Lautrec, of characteristic deformation and criticism of everything that was bourgeois. The artist conceded that he didn't have to please anyone. The eroticism of Toulouse-Lautrec or the Austrian Egon Schielle was at times aggressive or dramatic. That of Jules Pascin was melancholy, something toward Modigliani. The transparent eroticism of Picasso, who didn't save details from the public, had emancipated his nice social themes; nothing impeded integrating his fantasies.

Frantisek Kupka (1871–1957), Girl with Ball, oil on canvas. National Museum of Modern Art, Paris. Over the centuries, many paintings, mostly allegorical, have featured young girls. This particular painting is disturbing in its insinuations and hidden tension.

EROTICISM AS A THEME

The present day painter can come to the erotic themes without the censure of other eras but may continue feeling that his works might not be well received by the public. Each artist should be loyal to his own imagination and give it the right to deal with any theme that stimulates him. Only one factor is essential, that of sincerity in accepting one's own emotions. Eroticism is a theme that is treated in a topical and conventional way, when it is not false; accepted straightforward and elaborated with artistic intensity, it will always find viewers and buyers who can appreciate its value and profound human feeling.

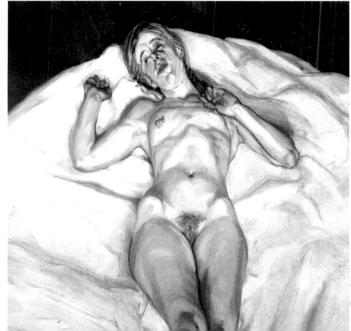

Lucien Freud (1922), Nude Woman, oil on canvas, Private collection. Here we see sensuality treated in a realistically shocking manner in its raw form. Freud's nudes are well known to many due to articles in mass circulation periodicals.

Eroticism in a scene can become more or less explicit. It all depends on the ability of the artist as a draftsman and what he considers to be his moral responsibility. In this figure drawing the artist injected good taste to a sketch that suggests an erotic activity.

The World of Genre Painting

Honore Daumier (1808–1879), Woman with Bundle and Child, oil on wood. The Louvre, Paris. This work is but one example of Daumier's involvement with painting and drawing scenes from everyday life.

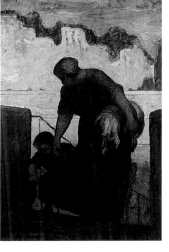

PEOPLE AT WORK

Artistic interpretation of daily work has important classical precedents. The realist painters of the 19th century wanted to offer a social testimony of life of the poor class. From these works came a tendency to interpret everyday work in dramatic or melancholy terms that speak to us of the dignity of the worker. But at the same time the opposite tendency existed, indicated by the vanguards of the 20th century: the recreation of the workers in an enthusiastic and optimistic tone, centering the attention on the effects of dynamic energy and action.

EVERYDAY LIFE OR GENRE PAINTING

During the Renaissance, and the many years leading up to it, artists kept busy with commissions to decorate the churches of Europe. Works of art were chiefly religious—Christ, His apostles, saints, martyrs and others whose stories were expressed with paint.

Eventually, these wholesale-lot church commissions dwindled. While there were still sizable church commissions, there were also demands for portraits from royalty, nobility, and anyone else who could afford them. Other artists happily found themselves free to express themselves in any manner they wished. They could now concentrate on the world around them, specializing in painting landscapes, still lifes, and capturing the activities of everyday life. These were the genre painters. Their works depicted everyday life in many different places, during many different eras. These artists found they could use their personal preferences to paint scenes and people that pleased them, without the concern of satisfying the tastes of a client.

Gustav Courbet (1819-1877), The Wheat Screeners, oil on canvas Museum of Nantes. Daily work has given way to many splendid works like this. The gestures, the attitudes and the characterizations play an essential role and give truth and strength to the theme. The work is realized in strict and sober realism. It's obvious the artist knew the work these woman did and represented it in its total human dimension.

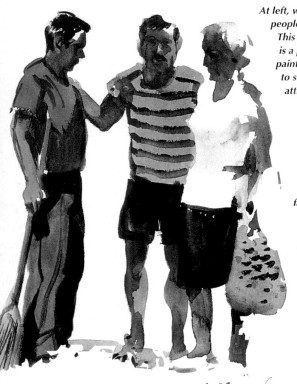

At left, we see a scene picturing people chatting on the street. This aspect of everyday life is a perfect theme for figure painting and an opportunity to study people in relaxed attitudes.

Ronald Brooks Kitaj (1932) The waiter, oil on canvas. Private collection. This painting, while extremely stylized and modern, also falls into the class of a genre painting. We have been programmed to expect all genre paintings to look like the others on this page.

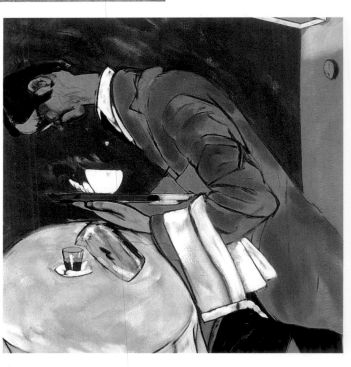

URBAN THEMES

Urban life offers so many diverse themes that it is impossible to analyze them all. From monumental architecture populated by figures, to night spectacles, there are endless interesting scenes for an artist. The city can be interpreted as a landscape or a background against which exists the action of the figures, like a special decoration that justifies the scene, or as a great dynamic organism which the figures complement.

Both possibilities were abundantly exploited by German expressionist artists. Painters like Grosz, Dix or Beckmann felt an exciting attraction for the greatness and misery of human life in the city. In their work, the autonomy of the individual was emphasized; the grotesque ways in which city dwellers interacted. For those artists, the variety of types, personalities and clothing was something that urban life provided.

Other creators, like Degas, saw the city as the natural scene for their figures, and treated them with careful objectivity occasionally intimate or compassionate to human activity. In the 19th century, another essentially urban creator, Honore Daumier, satirized with energy the bureaucratic and institutional state of Paris; the city and its daily life always floated around his figures, and in the case of washerwomen, another of his favorite themes, he shows how his artistic style could also encompass tenderness and niceness.

The diversity of urban vision that the artists have produced demonstrates that the city is the most contemporary of themes for a figure painter. In it, one can paint with major freedom without any of the conventions that impose themselves on a long artistic tradition.

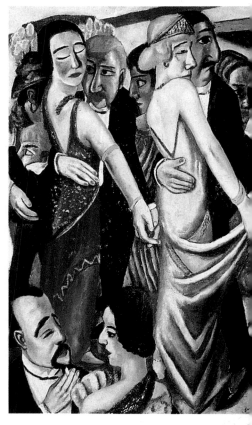

Max Beckmann (1884-1950), Dance in Baden-Baden, oil on canvas. Gallery of Modern Art of Bavaria, Munic. Parties, dances and social ceremonies are other attractive themes for a figure painter. In this case the artist was inspired by an elegant party and has represented it with a critical and satirical point of view.

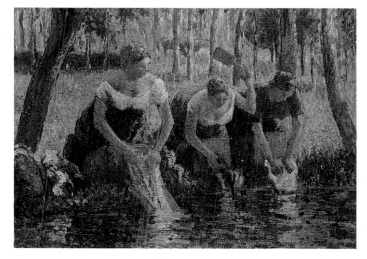

Camile Pissarro (1830-1903), The Washerwomen, oil on canvas. Private collection. Themes like this can't be found in a rural environment now, but the same way the artist has found the charm of this scene, it is also possible to find actual scenes with rural flavor.

Stanley Spencer (1891-1959), The Bricklayers, oil on canvas. Yale University, New Haven, Connecticut. City work is treated here in a very lyrical and personal style. The painter's fantasy gives the scene a celebratory tone full of the strength and dynamism of this work. Human forms here are symbolically parallel to the construction of the nests.

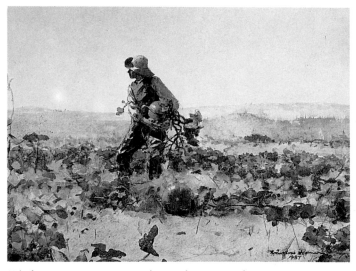

Winslow Homer (1836-1910), The Farmboy, watercolor on paper. Art Institute of Chicago. A work like this can be painted today in any garden of any rural zone. The theme is simple and is treated with great simplicity. The artist has recreated in the representation of color and form the leaves of the pumpkins and the figure appears central to the composition without unnecessary complications.

The Imaginary World

Odilon Redon (1840-1916), Woman with Open Arms, watercolor on paper. Petit Palace Museum, Paris. Redon was one of the best exponents of symbolist painting. The symbolists investigated the possiblilities of imagination in the creation of strange worlds. Although this feminine figure is pictured as a religious icon, the suggestion in the work is not totally clear.

FANTASY AND INVENTION

Edgar Degas said that a painting is a work of calculation: it is artificial to which one adds a small touch of reality to be loyal to nature. Degas was a great realist who knew some secrets of artistic work and was conscious of the arbitrary inventiveness that enveloped the most humble daily scene. From this point of view, all painting is the product of imagination. For some artists, imaginative elaboration isn't a road toward the representation of the real but a door opened to the creation of an invented world; a world recreated to realize ideals or capriciousness of the artist or in which impossible scenes develop from a realistic point of view, yet suggested by imagination. This directly affects figure painting; it is here that the artist's fantasy creates groupings, situations and invented scenes of major complexity.

MEMORY

Artistic elaboration of remembered scenes is one of the ways of working with an imaginative treatment of figure painting. It is not so much the strength of a true reconstruction, but a free interpretation of the elements found in memory, elements that combine with the real or obtained from other sources. One of the best to exemplify this procedure has been Marc Chagall. This Russian Jew exiled in Paris obtained his inspiration from his memories since infancy of a small village; this permitted him all kinds of fantastic combinations of figures and animals that contain a strong evocation not only of the rural life but also of legends and popular art. Memory deforms and idealizes, conserves that which leaves vivid and moving impressions, forgetting the rest; it is almost an unconscious process of artistic theme selection.

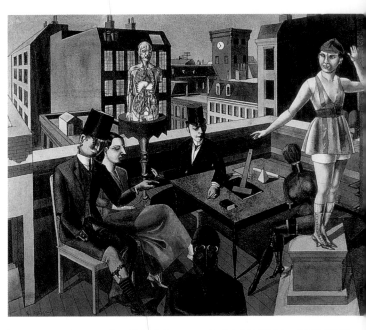

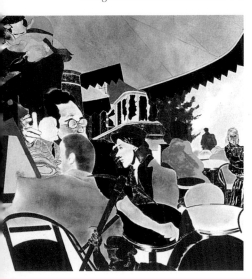

Ronald Brooks Kitaj (1932), Autumn in Paris, oil on canvas. Private collection. Although the figures may be treated in a work more or less conventional, the composition and grouping have an unreal feeling. Each figure is a personality that has a role in the scene, although this role is uncertain to the viewer.

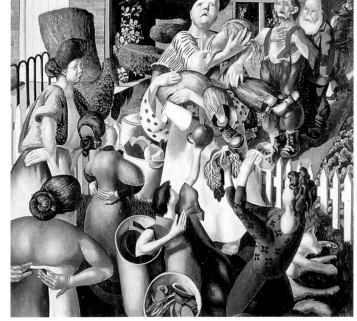

Rudolph Schlichter (1890-1955), Dada Workshop, watercolor on paper. Nierendorf Gallery, Berlin. The dadaists created disquieting images and scenes, incomprehensible from the rational point of view but full of suggestions, like surrealistic, dreamlike characterizations many years in the future. This scene is realized through free association of fantastic images.

Stanley Spencer (1891–1959), The Sweeper and His Lovers , oil on canvas. Lain Art Gallery, Newcastle. Life in a small village was the point of departure for this composition in which the painter let his imagination run wild.

SURREALISM

The surrealist movement, started in the years after World War I, revealed a new creative camp for the artist: the subconscious, the automatic involuntary, the free association of images. It broke with virtual logic. Surrealism is not an art without feeling but a freer comprehension of creativity in all the intuitions. Surrealists look to their dreams in search of themes, and many artists recreate their dreamworld. Naturally, not all the associations are equally interesting and here enters the conscious labor of selection and of order of these images of dreamlike precedence. All the works of this type, including the most surrealist, have a level of premeditated elaboration. The surrealist movement has made artists conscious that many improvised accidents can be of high artistic interest, opening new solutions in the realization of a figure or a scene.

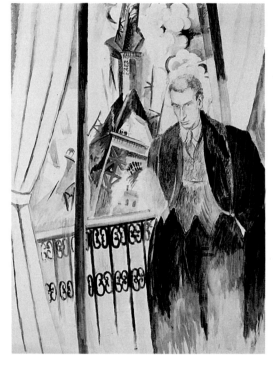

Robert Delaunay (1885-1941), Study for a Work of Philippe Soupault, watercolor on paper. Smithsonian Institution, Washington. This watercolor harmonizes two distinct treatments: realism for the figure and cubism for the tower. The counter position of both styles give animation and interest to the work.

Marcel Duchamp (1887-1968), Virgin #2, watercolor on paper. Philadelphia Museum of Art. Duchamp was a very imaginative artist who produced works in a variety of styles and formats. This composition reminds one of a machine or mechanical artifact, in clear counter position with what the title suggests. Duchamp was impassioned by play with this type of contradiction, searching always for the shock between artistic convention and the expectations of the viewer.

THE FIGURE IN MYTHOLOGY

Although the mythological painting doesn't exist as a genre, some artists continue to inspire themselves in mythological episodes. The figure of the Minotaur, for example, is one of the recurring themes in Picasso's painting, and many other contemporary artists of the painter found inspiration in the Greek myths. The motivations of these artists are not the same as classical painters who look for allegory in historic facts or the pleasure of their aristocratic clients ; the actual painter that is inspired in myths looks for an excuse to liberate himself from the real and give his figures attitudes, gestures, movement and a color more rich than what he can find in reality. The composition of scenes with nudes, for example, finds innumerable arguable justifications in myth: thanks to that thematic justification, the artist develops a motif rich in possibilities that everyday reality cannot offer him.

Most rare in actuality is the religious theme for painters. In contemporary painting there are no lack of examples by artists that have interpreted passages from the Bible. Myths, legends or any religious stories have prestigious themes, and one does not have to apply them conservatively as in past eras, but converted into exciting objects of the imagination can make way for works of great brilliance and originality.

George Grosz (1839-1959), The Ingenious Hearfield, watercolor on paper. Museum of Modern Art, New York. This scene has a humorous feeling that separates it from realism. Its brilliant color and the feeling of the composition make it very interesting from the pictorial point of view.

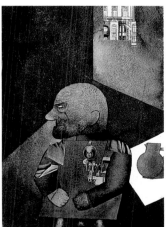

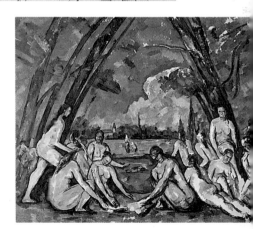

Paul Cezanne (1839-1906), The Grand Bathers, oil on canvas. Philadelphia Museum of Art. This famous composition is a free recreation of figures to the free air. From the point of view of realism, the scene is very improbable, but the play of forms that create the bodies have the highest artistic interest.

STEP-BY-STEP

Two Figures in Movement

Painting movement when dealing with moderate activities such as walking or working is difficult enough but when dealing with a lot of action, in this case, two cyclists, capturing the action is harder to do. Photos have to be used. Working from life only allows rapid sketches that are hard to elaborate and have to be left as they are. If I had decided to paint the entire work on location I would miss all the spirit that's derived from a rapid sketch. On the other hand, using a photo, I can work the figures in movement, resolving problems with calmness and optimism.

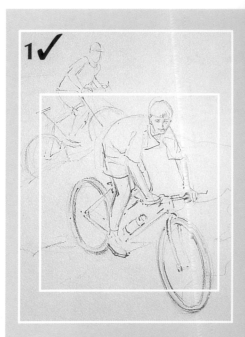

1 ✓

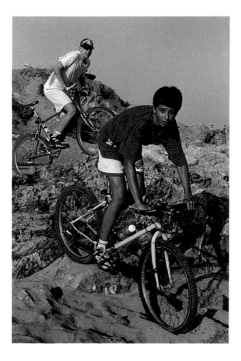

■ HELPFUL HINTS

The scale of the elements of my composition is a determining factor of space. When I adjust the sizes I am adjusting the distances. I should harmonize these sizes with the size of the paper and distribute them in a harmonious way: the distance between the two figures should be understood first without necessarily investigating and working with other elements of the painting.

■ THE PROCEDURE

Working with a snapshot, I am handicapped in the matter of injecting life to my painting. I have to concentrate on the problems of composition and color. Getting the rocks and terrain is the easiest part. They are inanimate. My interest is to situate the distances of the cyclists. Another interesting aspect from the start has been to correctly establish the size of the two figures because it is the unique element of the description of the space.

1 The situation of the two cyclists is merely indicated through some outlines that show the height and slant of the terrain. For the drawing we can already see that the figures and their bicylces at least can be resolved through blocks of pure color and will need, of course, lights and darks, even though the scene is plainly being enacted in bright sunlight.

STEP-BY-STEP

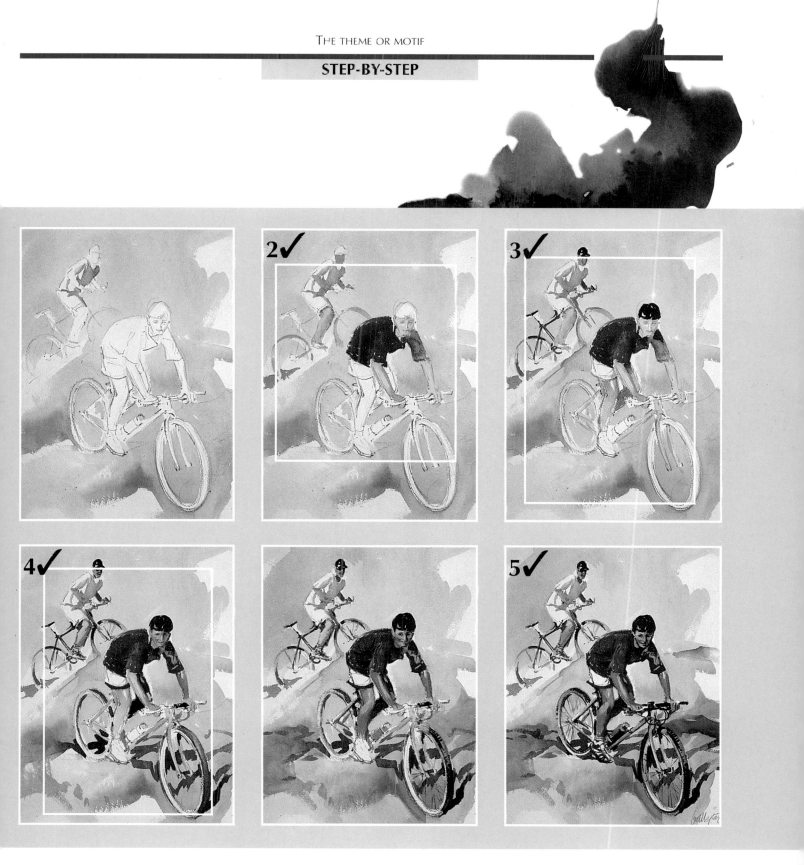

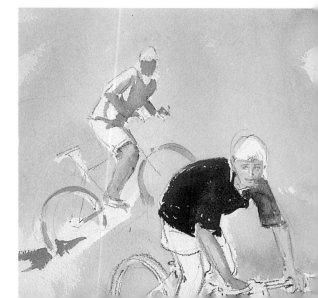

2 I begin to lay in my color. From the beginning, you can see how the values in the colors have helped to establish distance. The red of the closest figure is defined with pure Cadmium Red, while the figure further back is treated with gray. The sky and the earth have been chromatically reduced to push them into the background. In this step, I extended the colors over the paper with lots of water.

STEP-BY-STEP

3 In the previous step, the color of the watercolor, including the red shirt, was very pale. Now, having created a general harmony, I apply accents of dark tone that, in contrast to the background, stand out and give solidity to the figures. For example, in the front figure I have worked the form of the bicycle and the most intense shadows of the figure with touches using the tip of the paintbrush. In the figure that's closest, I paint the darkness of the hair and, at the same time, I begin work on the bicycle through strokes of Yellow Ochre.

4 I have hardly touched the figure in the background from my initial lay-in (adding shading in the shorts and light touches in the foot). The terrain is a little more blended, but not enough to mess up the image with many details. I have given a lot of attention to the fleshtones and the body of the principle figure: I add to the red blotch of the shirt, and I touch in some minor details to the face.

5 The finished painting (next page). I continue with the shadow on the bicycle and with additional shadows, I keep it on the ground. These last are irregular due to the bumpiness of the ground and this irregularity is what gives the idea of prominence in the ground I have darkened the fleshtones and have modeled the body to the illumination of the scenery. Although I may have used a photo as reference, I believe that this watercolor is a good exercise for a composition with figures that are held up for an instant, but still in movement.

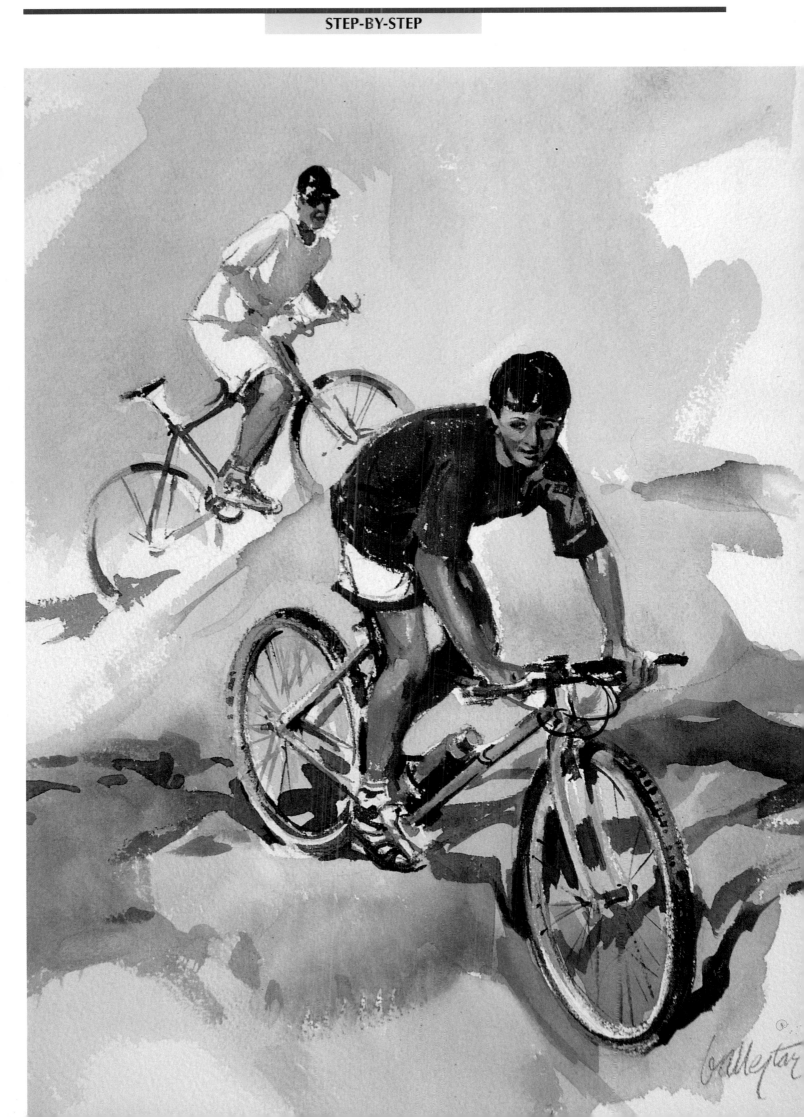

Color in Relation to Theme

Edgar Degas (1834-1917), The Absent, oil on canvas. The Louvre, Paris. The drabness of this painting is harmonious with the melancholy theme. This is treated with a realism that only emphasizes the expressions of the faces in harmony with the austerity of the interior.

HARMONY AND THEME

Each theme needs its own treatment and color. Through fidelity to real color of the scene, the artist always knows that certain chromatic harmonies exist that can function better in some themes than others. Warm harmonies are more appealing than cold; broken harmonies can be defined as more pensive. To each, chromatic harmony can relate to a state of mind, as the first abstract artists intended. All experienced painters know the links that bond color with psychology, and they try to utilize them in their work. It isn't possible to give a speech on harmonies and themes because they depend on the subjectivity of the painter and the viewer. But when a painter adjusts his colors to his theme, it is impossible to imagine that this same theme was painted with distinct colors.

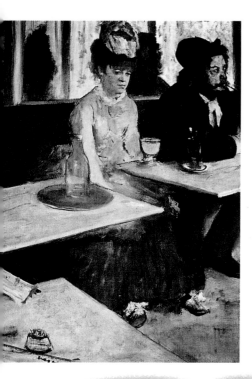

This sketch doesn't look for decorative effects and expressions, but is planted in a definite instant of daily life.

Emile Nolde (1867-1956), Small Faun, watercolor on paper. Private collection. The chromatic decision in this watercolor gives the figure a very intense facade. The expressionism of style distorts the features of this youth into a modern-day Bacchus.

THE SPIRIT OF COLOR

While there are theories of color, rules for the use of color and techniques for the mixing of color, the use of color in painting is at the personal discretion of each artist. The spark of the moment gives unplanned solutions that become a measure of the work. In such moments of inspiration we forget what is the norm, and that

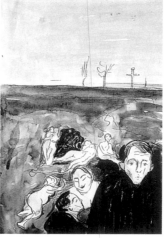

A use of color can effect expression. In this case, the grimace of the face is intensified by the strong contrast of complementary colors (blue and orange) that injects a belligerent note.

David Hockney (1937-), The Collector, acrylic on canvas. Private collection. Simple and decorative colors for an imaginary, cariacature-like theme that is clearly modern.

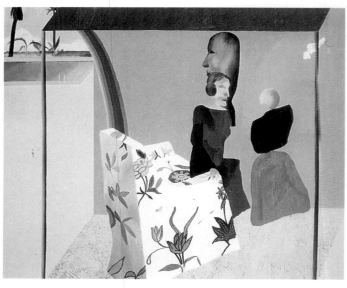

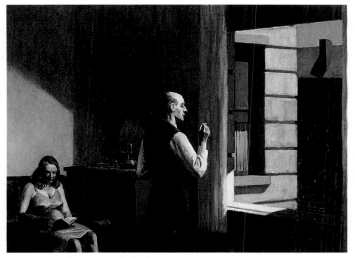

Edward Hopper (1882-1967), Hotel Joining the Street, oil on canvas. Smithsonian Institution, Washington. Although at first sight this work seems a literal reproduction of a real moment, the work is based on a careful selection of motif and an almost theatrical interpretation of it, with an important emphasis in the architectural environment.

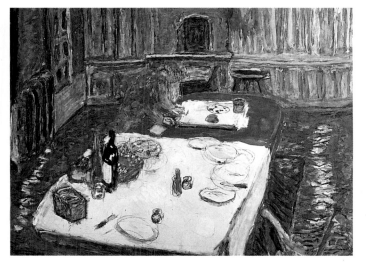

Pierre Bonnard (1867-1947), Preparation for Lunch, oil on canvas. Art Institute of Chicago. The intimacy of this work is of a particular atmosphere that responds to the direct experience of the artist. In daily dealings with these objects, the painter finds the formula to reproduce the special climate that reigns in this home.

instinct and personal feeling dictate color. Two distinct applications of color are difficult to compare: some artists use it in abundance and others more subtly with smaller tones. The only valid advice is that we may have confidence in our own possibilities and that we bring our own instinct and our own enthusiasm to each choice.

ATMOSPHERE AND COLOR

The atmosphere in a work is the air that surrounds the figures. Atmosphere should be fluid, continuous and without interruption. Color can create this atmosphere that's so necessary for interpreting the scenes in a completely artistic feeling. The combination of warm and cold tones, the quality of the colorations, the spatial sensations created for contrasts, all should respond to the atmosphere of the theme. Some artists speak of the air that circulates through successful paintings. The air also has color, the atmospheric color that unites the distinct colorations and the different figures. When chromatic harmony of the painting is successful, the atmosphere of the work is suggested and appears through that.

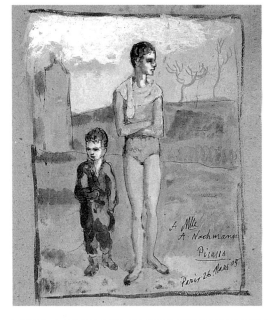

Pablo Picasso (1881-1973), The static quiet of the people in this work find an echo in the desolation of the countryside in the background of the scene

The tone of this watercolor is all in the gesture of the figure, sufficiently explicit so as not to need major additions.

RANGES AND SCENES

Working within a range of color (cold, warm, or broken), contrasting tones introduce mixes of other ranges: intensifying, harmonizing, softening, etc. All this brings vista to one result: the general harmony of the work. General harmony succeeds when the painting has arrived at a point in which all the colors and forms support each other and accommodate each other, giving way to what we call "chromatic accord," much like musical accord, containing multiple tonality but one solo sound, a solo harmony. The harmony has its own chromatic temperature that comes of light and through the general flavor of the scene, through the presence of pure colors and degraded colors, through the suggestion of details, and incidental lines.

Making Things Look Real

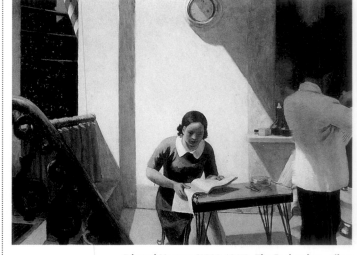

Edward Hopper (1882-1967), The Barbershop, oil on canvas. Neuberger State Museum, New York. The intelligent use of light centers attention on the feminine figure.

Norman Rockwell (1894-1978), The Novice, oil on canvas. The Brooklyn Museum, New York. This is an example of extreme realism. The virtuosity of the painter is impressive; he is capable of rendering the smallest detail including the crowd in the scene. Even though Rockwell earned his celebrity as an illustrator, principally magazine covers, can we deny the artistic merit of the work?

Winslow Homer (1836-1910), Eight Bells, oil on canvas. Addison Gallery of American Art, Andover, Massachusetts. This scene with its accurate representation justifies the realistic treatment by the painter.

REALISM AS ATTITUDE

In figure painting, a realistic treatment by the artist will be in favor by most of the populace. The artist who maintains this attitude is more impassioned by a viewed scene than a group of imaginative forms. His inspiration is found outside of the painting rather than in the painting style. The artistic quality of his work is the element that can create interest and carry the theme. From this point of view, the painter can have a style that is not rigorously realistic, but his posture is that of realism in the content of his work. There are multitudes of interpretations that can fall into this style; some of them very far from strict realism. We can recognize and understand this attitude by the artists who feel a curiosity toward a new world that surrounds them. They establish it in scenes in which the figure occupies the focus.

REALISM AS STYLE

Understood as historical pictorial style, realism seeks an almost documental likeness in themes and it is meticulous with figures, places and situations. The vigilance of realism continues to live and there are many painters who are intent to realize works that loyally reflect life in the contemporary world. Stylistically, the road is based in color that's limited by the dictates of the natural and composition narrowly linked with the reality of the theme. These practitioners are experts in drawing the human figure.

Honore Daumier (1808-1879), Game of Chess, oil on canvas. The Petite Palace, Paris. The realism of the theme is colored by the strength of the painter's style and by the drama of lights and darks.

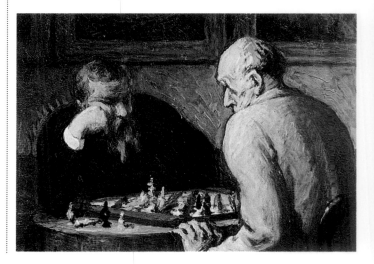

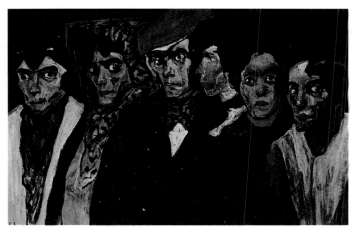

Joaquin Solana (1886-1945), The Sports, oil on canvas. Private collection. The treatment of these figures underlines and exaggerates their irrelevancy to the human drama.

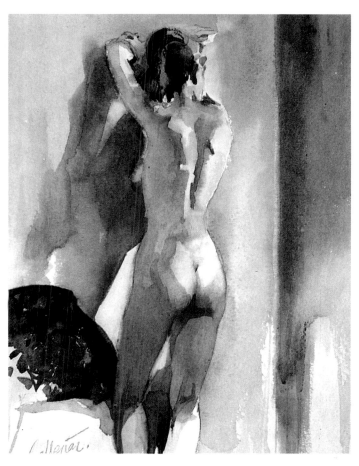

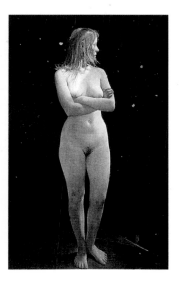

The qualities of this watercolor, at right, are enough to create the smooth sensuality of this work of Vicenc Ballestar. The realistic style of the artist does justice to the beauty of the nude.

Andrew Wyeth (1917-), The Virgin, tempera on wood. Brandywine Museum. Pennsylvania. The scrupulous realism of this work doesn't hide the intense emotional participation of the artist. It can be seen in the sensuality and extreme sensibility to the effect of the light on the fleshtones.

Frederic Bazille (1841-1870), Summer Scene, oil on canvas. The Fogg Art Museum, Harvard University, Massachusetts. The artist, whose life was all too short, was ahead of his time as evidenced by the modern treatment of the figures in his painting.

A MATTER OF IRRELEVANCY

Whether in the countryside or in urban surroundings, figures have to be relevant in their environments. The figure painter is concerned with providing a believable home for the figures in his paintings. Working with inanimate objects, still life painters still manage to become impassioned about fruits, vegetables, drapery and, of course, with all kinds of flowers. We expect nothing less from artists who involve themselves with painting human beings. While the very act of being human makes the figure as subject matter valid, it is incumbent upon the artist to paint it validly regardless of venue.

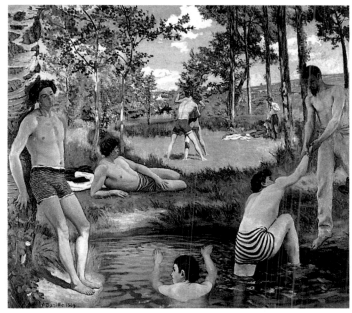

Andrew Wyeth (1917-), The Glory of Buzzard, tempera on wood. Private collection. The emotional closeness with the subject is the dominant tone in this ultra realistic work. Dense in detail and yet delicate within the framework of its light and dark patterns, there exists an eerily abstract quality.

Painting People Indoors

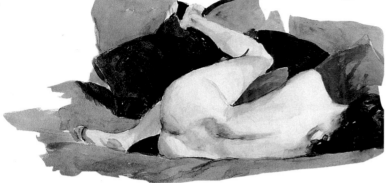

Edward Hopper (1882-1967), Nude, watercolor on paper. Whitney Museum of American Art, New York. Intimacy is an ideal theme for the treatment of the nude. This magnificent watercolor, which is quite a departure for Hopper, is an intimate peek at a supposedly sleeping model.

INTIMACY IN PAINTING

The intimate painting, as indicated by its label, deals with private themes, everyday life and the personal environment. Although we can find examples of this type of painting in very distinct styles and eras, the clearest references are found in the 18th century and in familiar interiors of the impressionists and post-impressionists. These works are void of all rhetorical or allegorical intention and are limited to establish artistically a moment of intimate life of people who in many occasions turn out to be the painter's family.

Edward Hopper, (1882-1967), Tables for Ladies, oil on canvas. Metropolitan Museum, New York. Here is an everyday interior, which is more in keeping with the painter's work. Hopper had a keen gift of observation, focusing attention on the accessory elements in relation to his human models.

John Singer Sargent (1856-1925), The Breakfast Table, oil on canvas. Fogg Art Museum, Harvard University, Massachusetts. A classic example of a painting of interiors. The bright, white tablecloth contrasts perfectly with the dark treatment of the dining room.

David Hockney (1937-), Devine, acrylic on canvas. Private collection. The colorful robe and background are expressions of intimacy.

PUBLIC PLACES

Public interiors: bars, restaurants, cafeteria, dance halls, etc., are environments that are not usually intimate in that we see the extroversion of people in their social time. This type of interior is very attractive, and very rare is the figure painter who hasn't painted works from this theme. So rare that one of the typical persons of these locales is the artist taking notes and making sketches.

What is certain is that there is nothing better for capturing gestures, attitudes, features and personalities than a public place in which each figure realizes a projection of his personality: persons drinking, eating, conversing, dancing, playing darts or in heated discussions. The artist can take side notes or initially organize the composition that gathers all the heat and flavor of the place and the people who frequent it. Toulouse-Lautrec's best work was inspired by and sketched at the Moulin Rouge in Paris.

Edward Hopper (1882-1967), Apartments, oil on canvas. Pennsylvania Academy of the Fine Arts, Philadelphia. The framed view suggests an exterior point of view, perhaps taken from a nearby house. The painter used architecture to balance the work.

INDOORS SEEN FROM OUTSIDE

A possibility less exploited than that of the interiors of public places is painting an interior from an outdoors vantage point. This has particular interest that relies on the participation of architecture in the composition of the work. The interior scene is cleverly framed, making it more objective and at the same time more human because the artist adopts the point of view of the passerby. Equally, it is very easy for the painter to gather material on this type of theme; he has to do no more than stroll on some street filled with people and armed with his sketchbook or camera and capture the moments in which these dramas come alive. A word of caution: be mindful of where you point your camera when photographing an interior from the street.

The attention to details of an interior accompany a keen study of the pose and gesture of the figure, shown at right. Both factors balance perfectly, in this monochromatic work, creating a sensation of the viewed scene and capturing the instant.

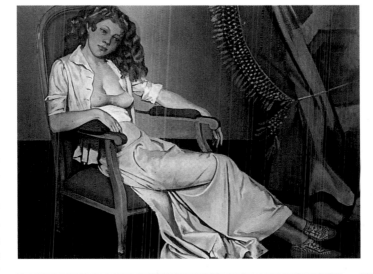

Balthus (1908), The White Dressing Gown, oil on canvas. Private collection. The artist's treatment of the model emphasizes the relaxed attitude of the young woman. We definitely have the feeling of looking in from the outside.

Giovanni Boldini (1842-1931), Dancer in Mauve, oil on canvas. Boldini Collection, Pistoia. The spirit of the artist's paintbrush and the choice of color are outstanding elements of this scene.

Edward Hopper (1882-1967), Movie in New York, oil on canvas. Museum of Modern Art, New York. An exceptional theme. This interior of a movie theater was painted during the showing of the film.

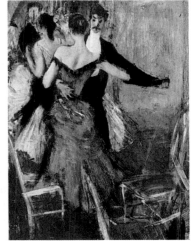

Outdoors: People at Work and Play

All artists are conscious of the immense thematic richness that can be found in the city's streets, not only in a typical activity, but in other scenes, like the one captured in the photo seen below.

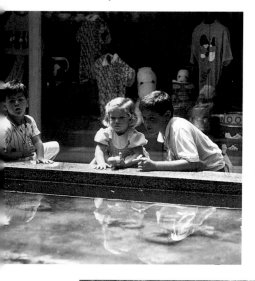

THE CITY ON STAGE

The city is a natural for figure painters. It is the theater of modern life, the decor before which the scenes play out without rest and where communication exists without interruption. The city is the grand theme of the figure painter. A grand theme that contains almost all themes imaginable. There is nothing lacking for an artist to discover in the immense quantity of interesting scenes that come before our eyes while we stroll the neighborhoods or parks of the city. The unique thing that is required is curiosity and to know how to see: to find behind the daily routine, the flavor of human life in its element, in its natural setting. The problem for the artist in the city, isn't finding his theme but deciding which theme to choose; such is the flood gate of

Edvard Munch (1863-1944), The Empty Cross, oil on canvas. Munch Museum, Oslo. These figures in the desolate countryside suit the moods and attitudes of the artist.

CHARM OF RURAL AREAS

Small populated rural areas aren't only for vacations or rest; they possess their own vitality, at times as interesting as that which is found in the city. This vitality has its own rhythm, slower than the great cities but equally dense in human qualities. A classic theme is the community center of a town where the same people gather regularly for town meetings and less heady social get togethers. The flavor of these scenes is incomparable and to figure painters it is difficult to resist their charm. And these themes are not unique to the town. In small towns we also find classical motifs of work in which the theme of rural figures in country life makes for a combination that can provide material that's as interesting as anything in the city.

Thomas Hart Benton (1889 1975), Tourist Field, watercolor on paper. Private collection. The point of interest for this artist is the vitality in his style as he recreates a scene during pre-war rural America.

Reginald Marsh (1898-1954), Fur Company of Hudson Bay, watercolor on paper. Museum of Art, Columbus, Ohio. Scenes like this show the artist's pleasure in street life. This painting of models in the window of an apparel shop is a testimony to the observation of the artist.

possibilities that are offered. An experienced painter knows the places and moments in which he can find his chosen themes: workers at work, street comedians and musicians, the right hour at the market, the newspaper readers, or simply the homeless people walking with nowhere to go. These are some of the many, many themes that can form part of a painting.

Andrew Wyeth, (1917-) Springhouse, tempera on wood. Delaware Art Museum, Wilmington. A banal and specific theme changes this work into a precious example of the artist's capacity for observation and great ability to paint a fascinating and memorable picture.

George Bellows (1882-1925), Under the Elevated Walk, watercolor on paper. Museum of Modern Art, New York. The city and its architecture populated with anonymous figures is the theme of this work. Industrial society, which at one time inspired pieces of social criticism, today continues to offer pictorial motivations to the artist.

Farmers are a traditional theme for figures in the country. This theme has always captured the attention of painters.

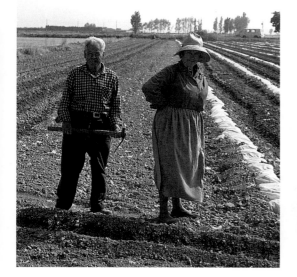

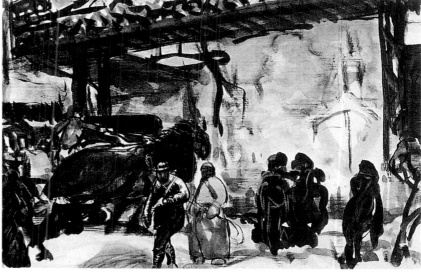

OUTDOORS SEEN FROM INSIDE

A view of the street from inside a room is an interesting vantage point. In the first place. it is a combination of two worlds, the closed world of the interior with the open and active world of the exterior. Here the painter can use all h s tricks linking or contrasting interior scenes with exterior scenes, creating a very rich game of relationships. In another way, the pictorial and compositional interest of this possibility is not to be overlooked: the frames of the doors and windows, the awnings and parasols, the tables, etc., are very adequate elements of which to make order and to introduce the necessary geometry in a composition of figures. The play of sizes and forms, the great contrasts between planes (figures very close and very far), games of light (shadow of the interior and the light of the exterior, or vice versa) are other such incentives that interiors offer us when interpreted as open doors to the outside world.

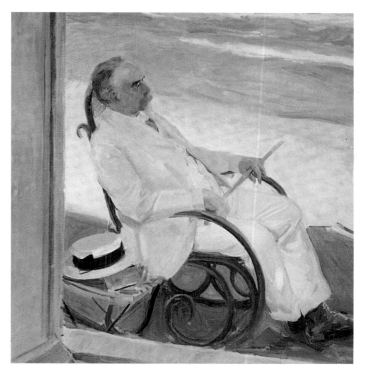

Joaquin Sorolla (1863-1923), Don Antonio Garcia on the Beach, oil on canvas. Sorolla Museum, Madrid. An inspiring impressionist theme: a scene seen from the interior, with the characteristic allusion to the window from where the artist is painting. In this case, the window modifies and distorts the format of the work.

Local Color: The Use of Natural Light

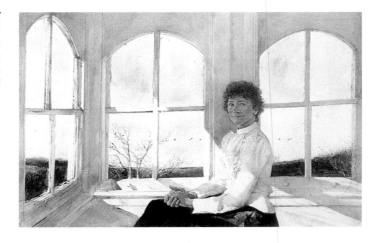

Andrew Wyeth (1917-), House of Crystal, tempera on wood. Private collection. In this painting, with the model obviously lit by daylight, the painter used this local color to create a natural ambience and atmosphere.

Local color is the true color of an object in ordinary daylight. In this lighting situation, the tones of the flesh are relatively unaffected.

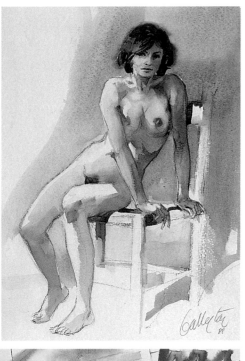

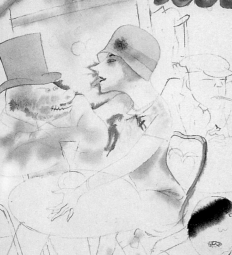

THE IMPACT OF LOCAL COLOR

A painting teacher, with tongue in cheek, once said, "The Old Masters weren't so gifted. They just didn't have electricity." It's true that the use of natural light resulted in a different kind of look than artificial light. Natural light, with its one source, the sun, produces clean, clear color and crisp, deep shadows. Highlights, in the hands of an experienced artist, look like more than just white spots on objects. In other words, painting with natural light makes a world of difference to a painting. While it's impossible to simulate natural light (or local color) through the use of artificial light, we can get fairly good results by lighting our subject with a well-placed spotlight that produces strong light and dark patterns, good cast shadows and a beautifully planned highlight.

Otto Dix (1891-1969), Suburban Scene, watercolor on paper. Ludwig Museum, Colonia. The interpretation in this painting, shown at left, enjoys the benefit of the local color, a pure, sun-lit representation.

Milton Avery (1885-1965), Bathers, watercolor on paper. Private collection. This work is a fanciful version of a real vision. The figures are reduced to colorful shapes.

PUT LIFE IN YOUR PAINTING

Life or vitality in a scene is, in good part, the creativity of the painter. Transferring the vitality in real situations to your painting is the result of the proper artistic language, the language of line and color. For the drawing to contain vitality it is necessary that no unnecessary complications exist. The figures are pictured, in what

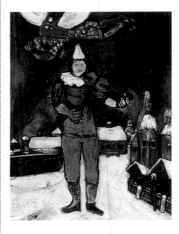

is indispensable, with combinations of lines and curves, with agile sketches and without the complications of unnecessary details. The emphasis on the free and rapid sketches is another vitalizing factor of the representation. For color, its vitality will depend on the type of drawing. A rich and expressive drawing doesn't need brilliant or explosive color because it already contains sufficient force in itself. When the drawing is functional and neutral it calls for explosive color full of contrasts.

But the drawing isn't automatically finished when we begin to apply color. The drawing and the color should be fused together in the finished work to the point that one cannot distinguish when one ends and the other begins. In painting watercolor this translates into colored sketches that unite the drawing and the color.

Marc Chagall (1887-1985), Snowing, watercolor on paper. St. Louis Art Museum. In this painting the idea of local color is enriched by a dreamlike atmosphere. The color as much as the form serves the imaginary ambience of the scene.

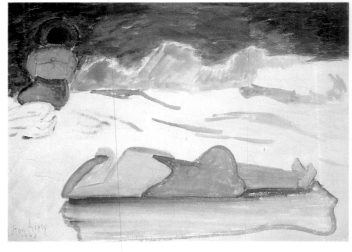

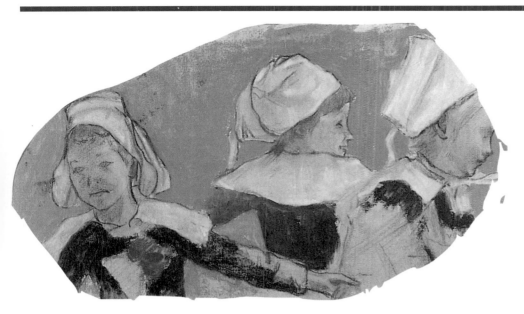

Paul Gauguin (1848-1903), Breton Dance, watercolor on paper. Private collection. The success and attractiveness of this small picture is due in good part to the naturalness of movement of the figures. The artist depicted a degree of naturalness in the characteristic movements of a popular provincial dance.

Giovanni Boldini (1842-1931), Emergence of the Dance of Masks in Montmarte. Boldini Collection, Pistonia. In this painting the volume of the movement represented in the street scene brings to the extreme the dissolution of forms in a mass of colorful brushstrokes. The movement of the brush parallels the movement of the horses and carriages.

FIGURES IN MOVEMENT

Capturing movement of figures is another immediately important point in representing a scene. Normally, peoples' gestures in these scenes are major characterizations which the viewer appreciates most in a work of this type. Capturing movements, varied and harmonious, is not easy work. In these cases, when the figures are everything, it works to begin with a photograph. But photos will have to always combine with a note of the natural, because they are the notes and sketches that really give the painter solutions to human renditions. The camera only gives a photographic version that helps the artist in the interpretation.

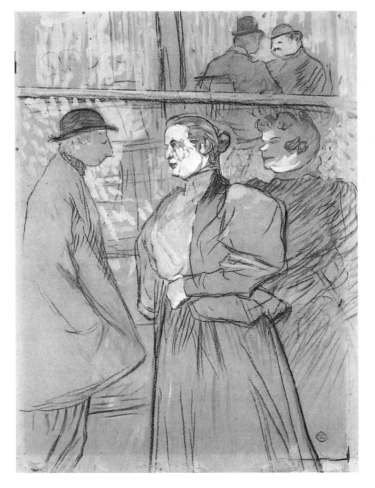

This rapid sketch, shown above, reproduces with precision a characteristic movement of a figure without necessity of presenting sophisticated artistic means. The artist, Vincenc Ballestar, doesn't need to represent the facial features to get the facial expression.

Henri de Toulouse-Lautrec (1864-1901), In the Moulin Rouge. Private collection. The static fixed quality of these figures gives the work a sculptural appearance but the always nervous and dynamic lines of Toulouse-Lautrec carry vitality and animation to a motif which, in the hands of any other painter, would not possibly have the same results.

Life on the Steet

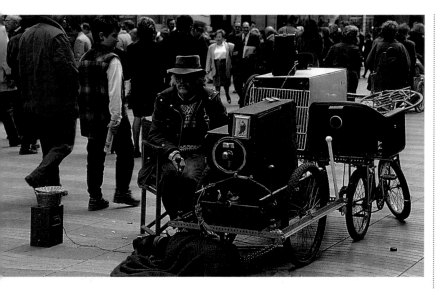

The street offers a symphony of themes, of motivations, of scenes, of spectacles. The great cities are full of possibilities, but also the small towns. The only requirement is curiosity and an observing spirit.

With equipment trimmed down for work in the street, the artist can situate himself in any corner and work directly from life, capturing all of its vitality and movement.

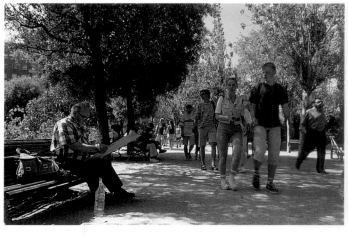

Street scenes are a favorite pictorial theme for the figure painter. It is the street theater where fantasy and imagination serve us.

URBAN LIFE

In previous pages the inspirational richness that urban life offers to the figure painter has already been mentioned. This richness finds itself condensed in street life, distinct in each city and always possessed of a characteristic personality.

Painting the life of the street signifies confronting a variety of people that is difficult for the painter to zero in on. The painter finds the wait interesting because the street always serves up something unexpected and a bit of a surprise.

Some of the more attractive street episodes are those in which enthusiastic people exhibit their talent on any corner and attract a ring of curious people around them. One of the curious can be you, the artist, armed with your sketchbook. It is a good idea to also have the assistance of a camera to make these representations easier once back at your studio.

THE PASSING PARADE

Seated on a bench, on a street or in a park, you can practice by sketching the parade of passersby. The idea can be simply covering the paper with all types of finished and unfinished figures. But also you can have a precise idea of doing a larger piece at a later time. On these occasions your memory is fundamental, although techniques exist to help you. One of these techniques is to capture it all through small characteristic features. Features like the curve of the back and the shoulders and the positions of the legs, or to get only the gesture of the head, leaving the rest of the body in a sketchy way. And don't forget that camera; it should be an integral part of your sketching equipment. We can't stress strongly enough the value of taking photos for later work in the studio.

Otto Dix, Street Scene, watercolor on paper. Private collection. This is a street scene that has been loosened up through caricature, one full of observation and a certain kind of affinity with reality.

Edward Hopper (1882-1967), Blue Afternoon, oil on canvas. Whitney Museum of American Art. The carnival always provides artists with colorful and interesting models.

A GROUP OF PEOPLE

One of the most interesting themes in figure painting are groups in the street. The brightness of color, of the clothes and the variety of expressions change them into pictorial members that create curiosity. At times these spectacles are limited with the caricature, including the grotesque. Humorists or comedians, clothed in fantasy clothing discover unsuspected motifs that have not crossed our imagination before. In one of those spectacles, the artist can walk imperceptibly while taking his notes and doing his sketches.

Balthus (1908-). The Street, oil on canvas. Museum of Modern Art, New York. This work is symbolic of street life. Each figure personifies a type of worker or bypasser.

August Macke (1887-1914), The Mode, watercolor on paper. Ludwig Museum, Colonia. A stylization of color and form that displays all the elegance and charm of an everyday episode.

George Grosz (1893-1959), Proslavery, watercolor on paper. The Lander Museum, Darmstadt. Urban life is condensed in a mass of lines that appear in the background of the scene. The central figure dominates the stylized composition.

Maria Fortuny (1838-1874), The Clerks (detail), oil on canvas. Private collection. A customary scene that gathers the flavor of a form of life captured in a naturalist and objective style.

STEP-BY-STEP

A Drama in the Street

Every once in a while, an artist is fortunate to come upon a scene that is not part of the usual routine. In this case, it became an unusual setting for an unconventional painting. Along with a few dozen other people looking on, I saw a model (a street actor) being made up by her colleague. I might add, at this point, that for many years groups of these people have been prevalent in many of the parks of European cities and have recently begun appearing in large cities of the United States.

The young woman was wearing a white dress and was being painted in white, like a living statue. I didn't have my camera with me, but I made sketches to supplement my mental image of the scene. The white of the woman apparently was the key to this scenario.

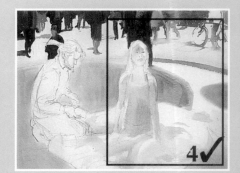

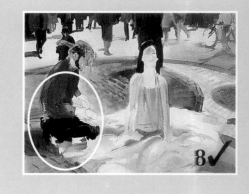

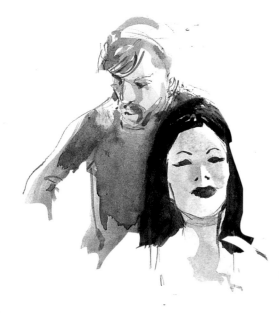

■ **HELPFUL HINT**

The sketches shown here ended up providing me with enough material to be able to design an interesting and compelling composition.

1 The drawing at right (page 89) is the result of sketches I made at the scene. The interest is in representing the drama in the street. I don't want to isolate the figures from the background; they both have to be integrated into one provocative piece.

STEP-BY-STEP

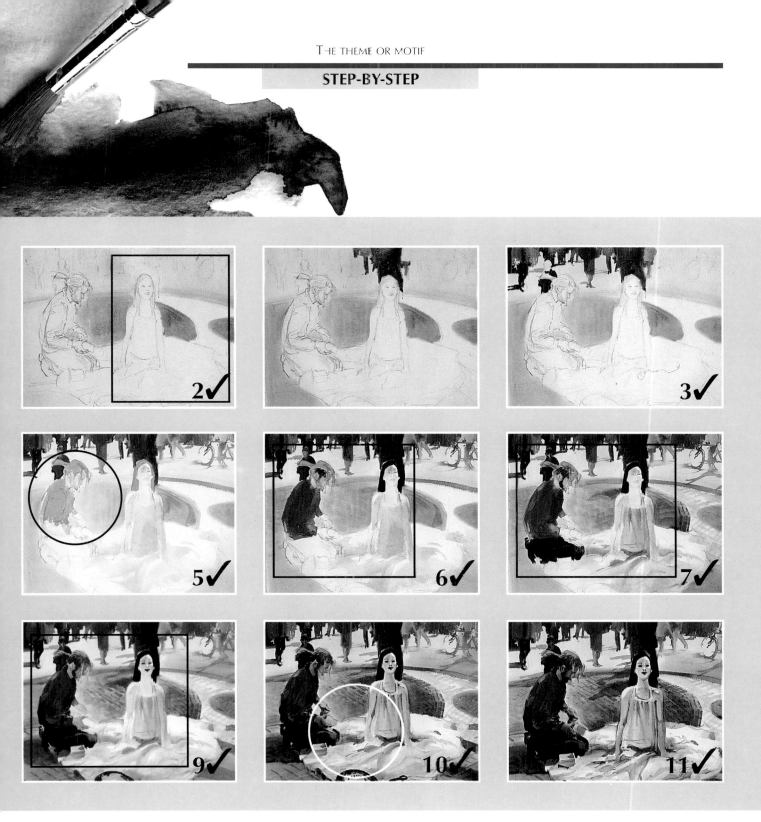

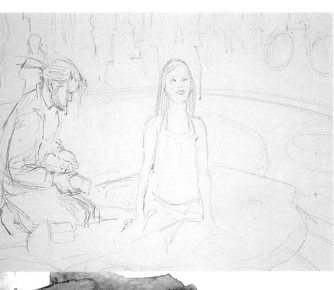

■ THE PROCEDURE

When I started to paint this watercolor, I decided to respect the initial grays in the final result. Contrasting these grays with the color of the other figures heightens the theme. In fact, my intention was to "colorize" everything in the painting except for the focal point—which is the living statue.

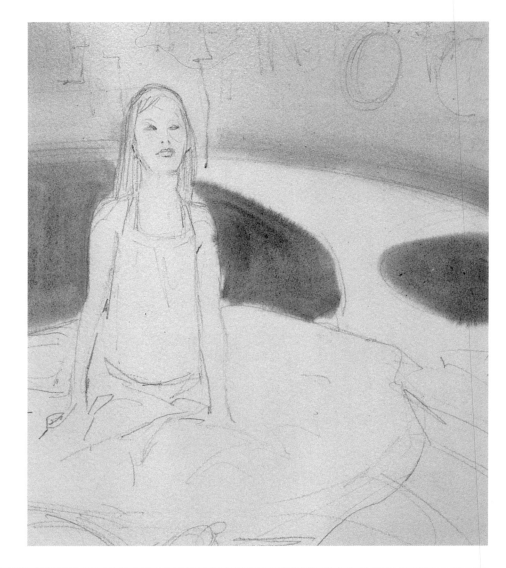

2 I first mixed grays over a previous yellowish wash which I used to cover the paper. It was very thin, very soft, which I used to give a very light tone to the figures. In the closest part, these grays have a bluish tendency.

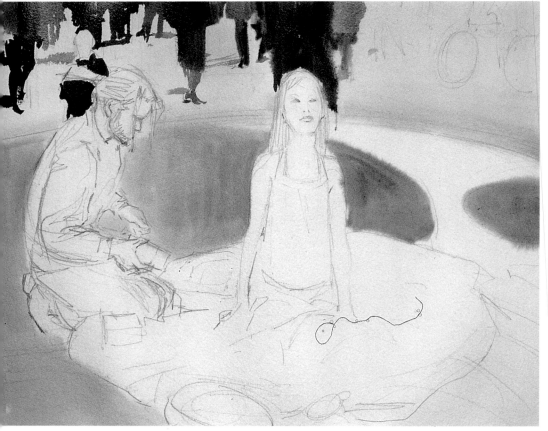

3 These blocks of color represent the people watching the drama. The color can be interpreted as people, thanks to the changes in the tones and to the indications of arms and legs. They were put in rapidly, without waiting to dry and with the addition of some significant detail, like the legs, the shoes and the shadow of the person to the left.

STEP-BY-STEP

4 Notice how I have painted the bicycle in the upper right part of the composition. It is painted sketchily; you can see the bicycle's shadows more than the bicycle itself. Almost the whole top part of the picture is painted with very free blocks of color that suggest the people.

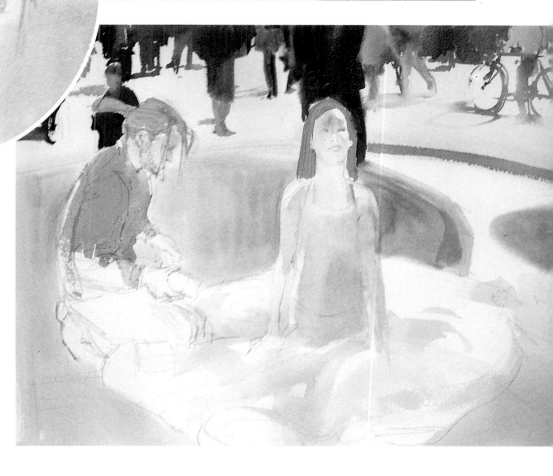

5 I begin to paint the figures. To help me form the head and hair of the young man in the foreground, the small figure behind him in the background acts as a dark screen against which his pigtail stands out. I work the girl very delicately, a base of watered-down grays, of mixes and values of the same tone to play up to her whitish coloration.

STEP-BY-STEP

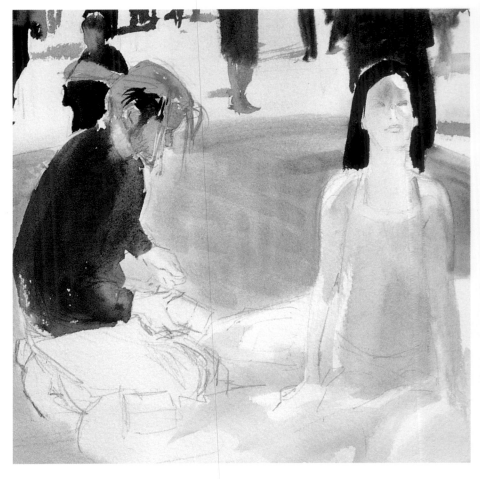

6 I'm going to intensify the colors of my starring players. Just as I have placed a dark tone behind the head of the male figure, I have placed a very dark figure behind the girl. While her dark hair combines with the color that appears behind it, the body of the girl is gently modeled in contrasting grays, using a lot of water to make the tones transparent.

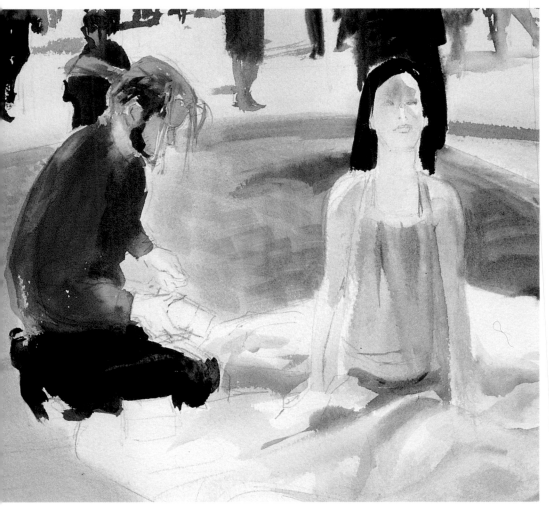

7 I define and establish the level of the ground in two ways; in the first place, I color the pants of the man, which gives him a base. The second way is a series of strokes that represents the cobblestones on the ground. These strokes should be made practically of dirty water from the mixes because I don't want them to stand out.

92

STEP-BY-STEP

8 Now it's time to add shadows. For this, I work with a very restricted range of grays. On the ground, I have shadowed the strokes to emphasize the representation of the cobblestones.

9 I purify the form more and more. The folds of the girl's dress are defined now much better than before, giving them a more precise volume in spite of their sheer fabric. Also the young man is much more finished, showing more detail in the head.

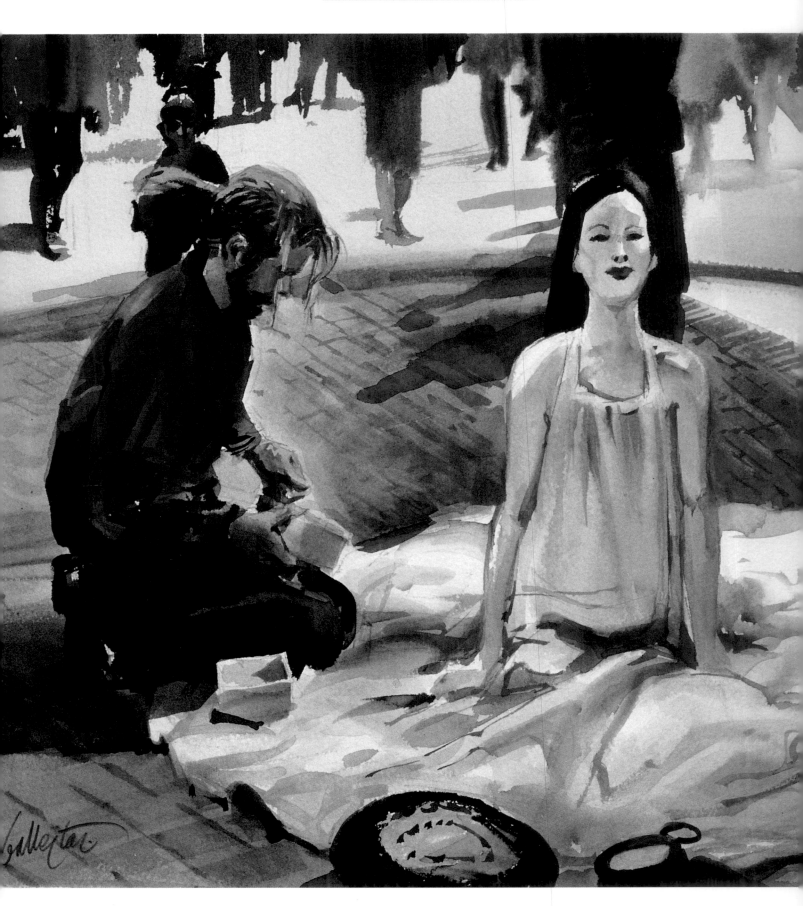

11 It is interesting to take a look at the finished painting. It contains enough form and detail, yet maintains the light and floating atmosphere of the unfinished stages. This was my intention: to balance a realistic figure done in whites and neutral tones, with the other figure painted in full color.

STEP-BY-STEP

10 I'd like to go back to the step before the finish. Here we see the facial make-up on the girl. The rest of her body is simply shaded with very transparent grays. This contrast between the transparent grays and the ground is one of the principal interests of this step-by-step progression, in that I have decided to make a radical separation between the grays and color.

STEP-BY-STEP

The Theater as Inspiratic

Welcome to the theater. Figures from the stage dominate the last portion of this book. I must confess that the theater is one of my favorite figure painting inspirations. It can be fun for you, too. Everything in it is exciting: movement, color light effects, combination of figures, dynamic compositions, and other elements that stimulate the artist. And what is most important—diversion. If there isn't diversion in a painting, it's hard to get anything that's interesting. Diversion is enthusiasm, passion, illusion of obtaining something new and different. All of this is seen in the musical theater, mainly the brilliant spectacle of dancers in their colorful costumes.

■ THE PROCEDURE

In this demonstration, I am looking for light. Interesting illumination creates dynamic and pictorial value on each figure, because each of them is affected by the light in some way. The darkness reveals certain parts of each figure and those visible fragments compose a pictorial choreography. The procedure, moreover, goes from the complete figure to the fragmented figure using strong dark and light patterns (*chiaroscuro*).

1 I draw more than I can see; I draw the complete figures, as if they were strongly illuminated. I need to control the form from the start in order to be able to play with it afterwards. It is very important to control the relative sizes of each of the dancers because it dictates the proportional resolution of the scene.

■ HELPFUL HINT

To deal with these themes it is important for the painter to have gone to the theater many times to see the spectacle and take notes and make sketches; the more the better.

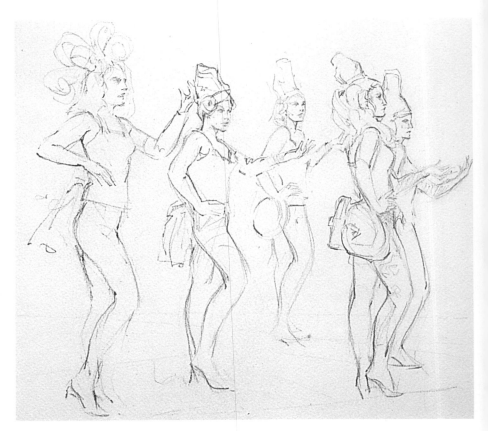

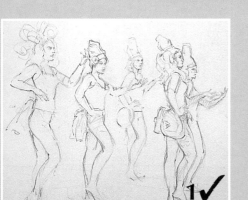

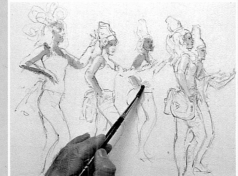

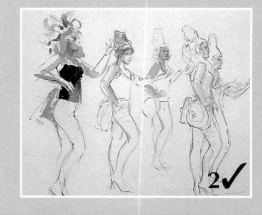

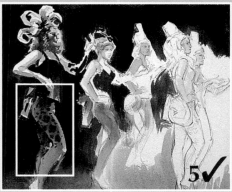

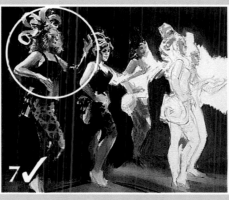

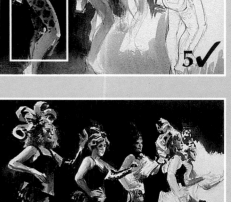

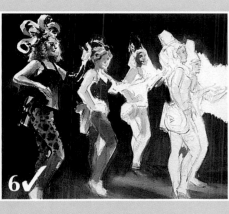

STEP-BY-STEP

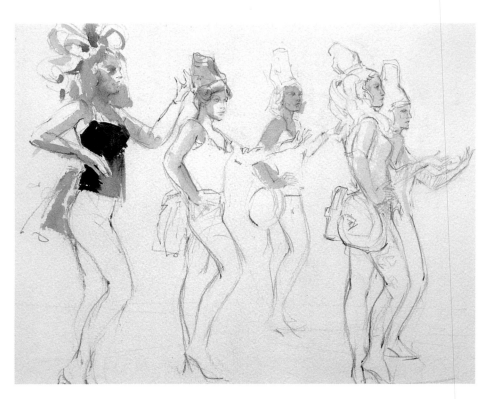

2 I paint the fleshtones and some other touches, which will illuminate the finished figures completely. In preparation of the play of lights that will come, I do not complete these fleshtones; I leave them loose through some rapid brushstrokes.

3 As I begin to paint the dark color of the background (in reality, a very dark violet), you can already see my initial intentions: the areas of the dancers' bodies without any paint, are the areas most affected by the bright direct light.

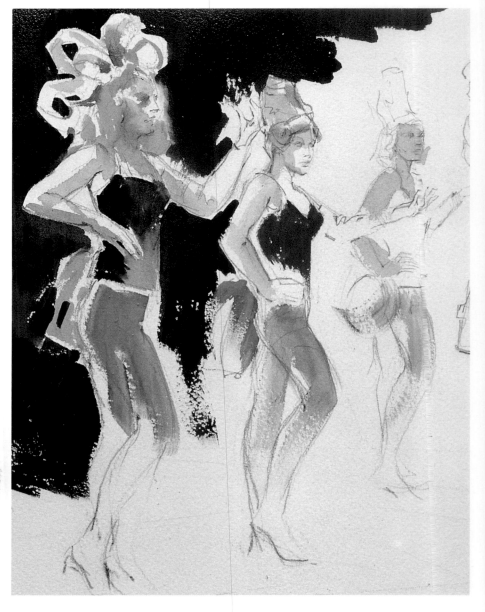

STEP-BY-STEP

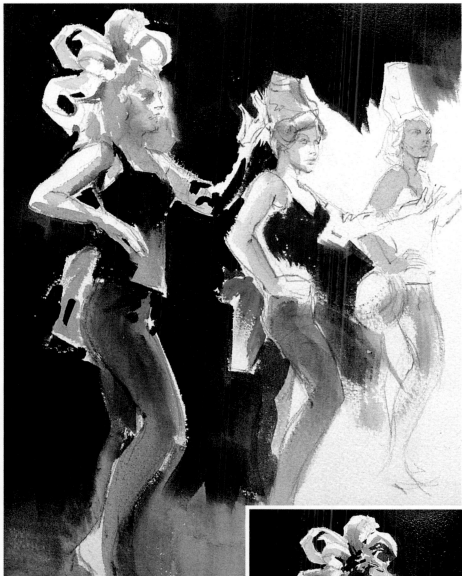

4 Now I proceed with the background which helps develop the forms of the dancers. The figure on the left of the composition has already received a first *chiaroscuro* treatment that lets you see the blouse and the pants. The blouse gives the first contrast of light and shadow that helps to define its form around the body of the dancer; the leg also gets a strong contrast, a darkness in the central area that helps to round it off.

5 The figure on our left is almost finished. Prints are painted on her tights. The shadow calms down the contours of the blouse and creates a rich play of shadows. The detail at left shows this clearly.

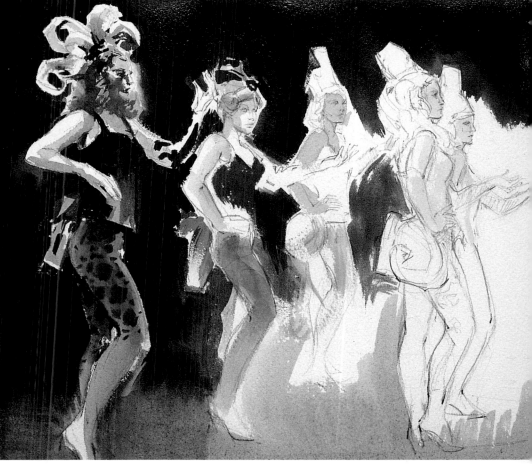

STEP-BY-STEP

6 Now the whole background is almost completed. I will repeat on the other figures, the treatment that I gave to the figure on the left. The forms of these figures, which were drawn with detail, are now blurred, having lost their clarity or, better said, the previous lineal clarity is now substituted by a definition of the form in terms of light and color.

7 Now the dancers begin to blend into the background, to truly be part of the theatrical atmosphere of the scene. You can prove this by the darkness on the legs and the body that make them disappear into the darkness. I have here one of the great attractions of the benefit of *chiaroscuro* and theatrical backlighting: they create forms that appear and disappear.

STEP-BY-STEP

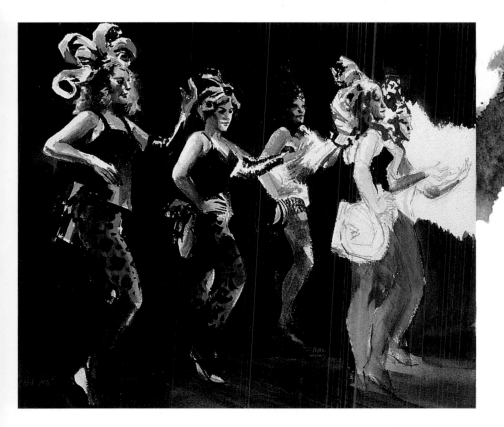

8 The clarity is not as definite as it was in the beginning of the painting progression when the watercolor was still sharply delineated. The figures seem alive now, real nocturnal beings that develp a scenario. The headdresses and the clothing have character within the play of lights and darks.

9 Little by little I am finishing the watercolor toward the right, working the figures more each time, hiding them more and more in the darkness of the scene. It is a work of selection, of searching for that which produces a purely dramatic effect. I am not interested in the detailed description of each figure but what I find most spectacular about this scene, is the theatrical lighting.

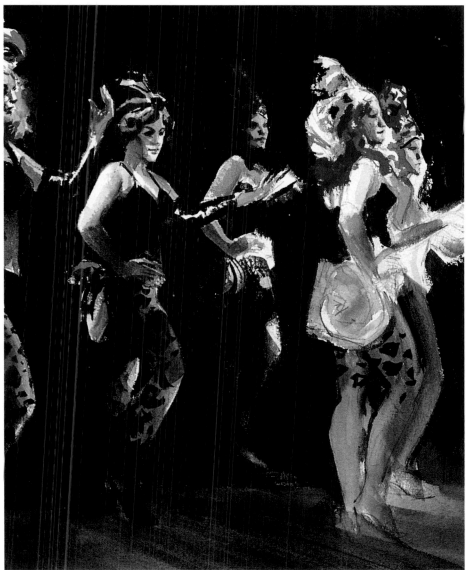

STEP-BY-STEP

10 The blouses have almost completely disappeared, they are lost in the background. Nevertheless the eye is able to "see" where there is no form and unconsciously reconstructs the form of the body in the darkness. Thanks to my careful drawing, I was sure of the poses of each dancer.

STEP-BY-STEP

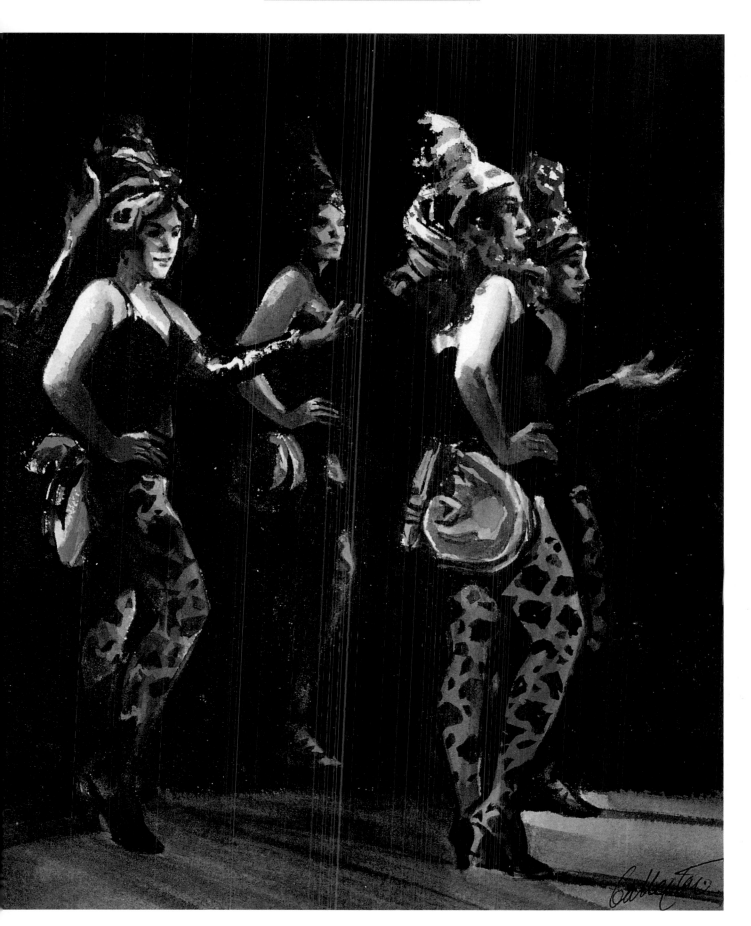

11 The work is finished. *Chiaroscuro* does not fight with color; the points of maximum luminosity are also those of more explosive color. The watercolor has moved to a high level of satisfaction, a level that was indispensable for painting a good picture: one of my most agreeable themes in the medium of transparent watercolor.

STEP-BY-STEP

Artists and Their Paintings of Intimacy

You can't have a book about figure painting without devoting space to the nude female. It is the pictorial theme to which all figure painters always return and which has gained the most popularity in history. We have spent time with this theme earlier; we present it now as a preface to the pages that follow. Therefore, I have searched for a version that's distinct from the customary: the intimate nude. It seems to be the right time to offer in total detail the development of this theme. It's evident that all works of art have their own history. The artist arrives at the final result after trudging a long road over a career. It's interesting for the reader to be able to see how we have arrived at this point and how this has crystalized into the final result.

The method that we have pursued throughout this book, now culminates in painting a figure in intimacy. The theme offers the lack of inhibition and the freedom that one has, and it protects any expression that's awakened in those who view the works. For our documentation, we reproduce the works of a group of painters, true masters to many, and, obviously, outrageous to others, to show some examples as a way to demonstrate their treatment of the female figure in this way.

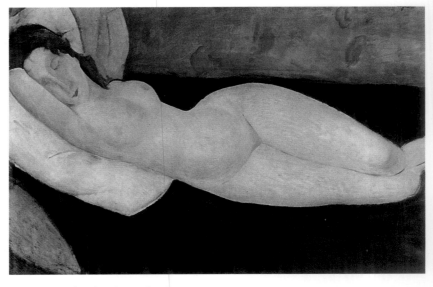

Amedeo Modigliani (1884-1920), Nude Sleeping, oil. Collection of Madam Rudolph Spinner, Zurich. This work, painted when the artist already knew that his death was to arrive soon, shows his zeal to finish a work in a single session and his obsessive preoccupation to raise his works to a high level of esteem. The artist has perfectly resolved the sensation of quiet and calm that animates this figure with a great balance between the solid volume of sculpture and the lineal rhythms in the piece.

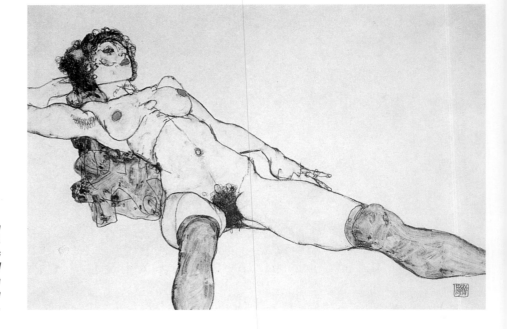

Egon Schielle (1890-1918), Nude Woman (1914), painting of wash and pencil. Graphische Sammlung, Albertina, Vienna. This nude, very far from the moral canonized traditions, offers to the student the body of a nude woman that possibly is more explicit than many art students can be comfortable with.

STEP-BY-STEP

Gustav Klimt (1862-1918), Half Nude Woman Sleeping, pencil. Over a matte background, the artist uses a pencil with a very fine stroke to draw the figure as if floating. She is completely relaxed in her dreams and fantasies. Here the impression is transformed into expression. With great care of the composition, the artist obtains a drawing full of spontaneity, sensuality and eroticism. Klimt liked to use this technique in treating the bodies he chose to delineate.

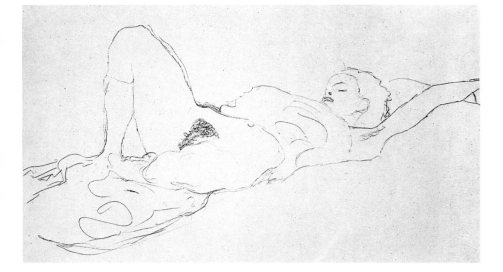

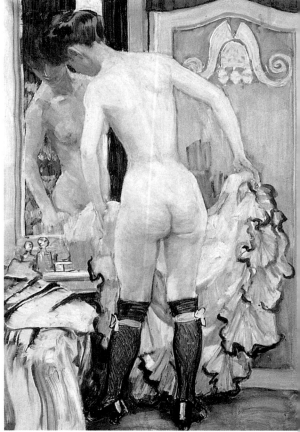

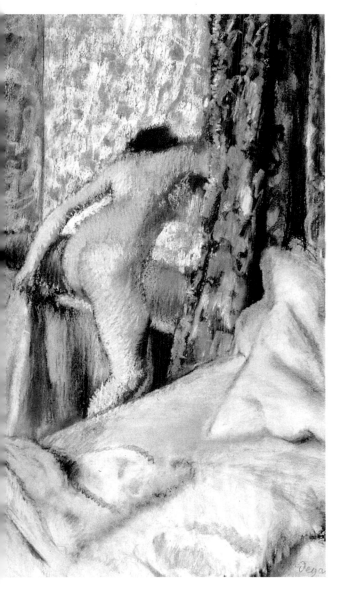

Edgar Degas (1834-1917), The Morning Bath, pastel. The Art Institute of Chicago. Here is an example of the great artistic possibilities that are offered in a simple theme. To the base of greens and blues, Degas has given the figure an intimate and delicate tone, contrasted with the clothing and curtains that are incorporated into the scene.

Frantisek Kupka (1871-1957), Woman Before A Mirror, oil on linen. Narodni Gallery, Prague. This artist, filled with the ambience of Paris, presents here a scene of everyday life, full of sensuality, in which the nude body is accompanied by a number of ingredients that place the work in an area that's suggestive of scenes from Degas or Toulouse-Lautrec.

Edgar Degas (1834-1917), After the Bath, pastel on Bristol cardboard. The Hermitage, Office of Drawings, St. Petersberg, Russia. We see a work which demonstrates the complete talent of the artist. The artist achieved an attitude of the woman and a bold balance between the pose—very near the classical forms—and the decorative. It is a cool decoration but the orange room fits the blue of the towel.

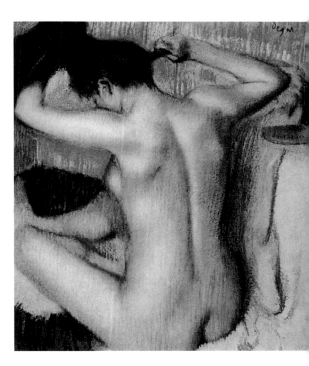

STEP-BY-STEP

Painting a Nude Figure

STUDYING THE MODEL

My motivation was to get an intimate scene in the manner of Degas, one full of spontaneity and freshness. The movements and actions of this young woman were photographed in the morning upon her leaving her bed. Reproduced on these pages are but a few that we took; we have many more. Almost all of the photos could have served as a theme for this work.

The complete sequence of photos, sketches and watercolor progressions that will show you one way to paint a female nude, covers ten pages. The step-by-step progression starts on these two pages with the reproduction of five photos of the young woman in her room. The photo I chose to paint is not one of them.

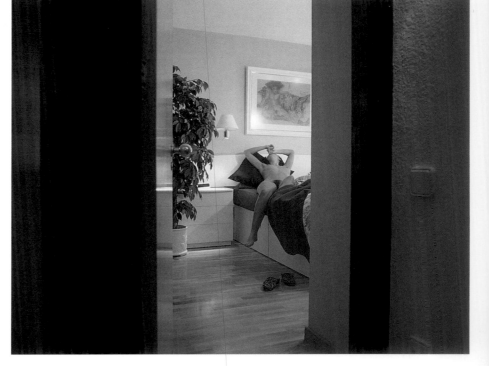

None of the sketches I made on pages 108 and 109 look "photographic," even though I used the photos to work from. The sketches are spontaneous and vibrantly alive. You should remember that in an exercise like this one, what you draw or paint shouldn't be a mechanical representation of the source material; it should be the result of attentive observation of the subject, in this case, the young lady, to produce a fresh-looking interpretation of a subject that has been painted by many artists over a number of centuries.

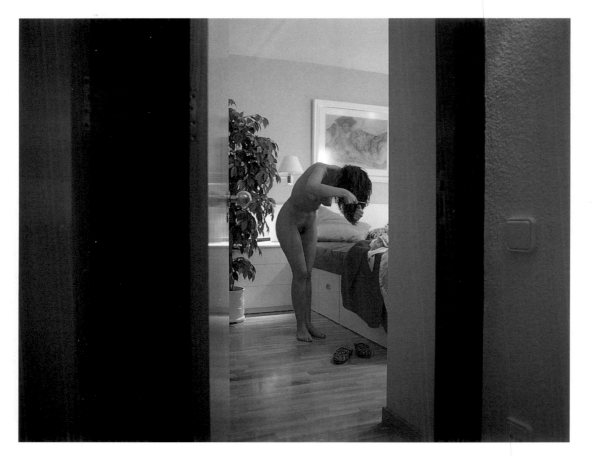

STEP-BY-STEP

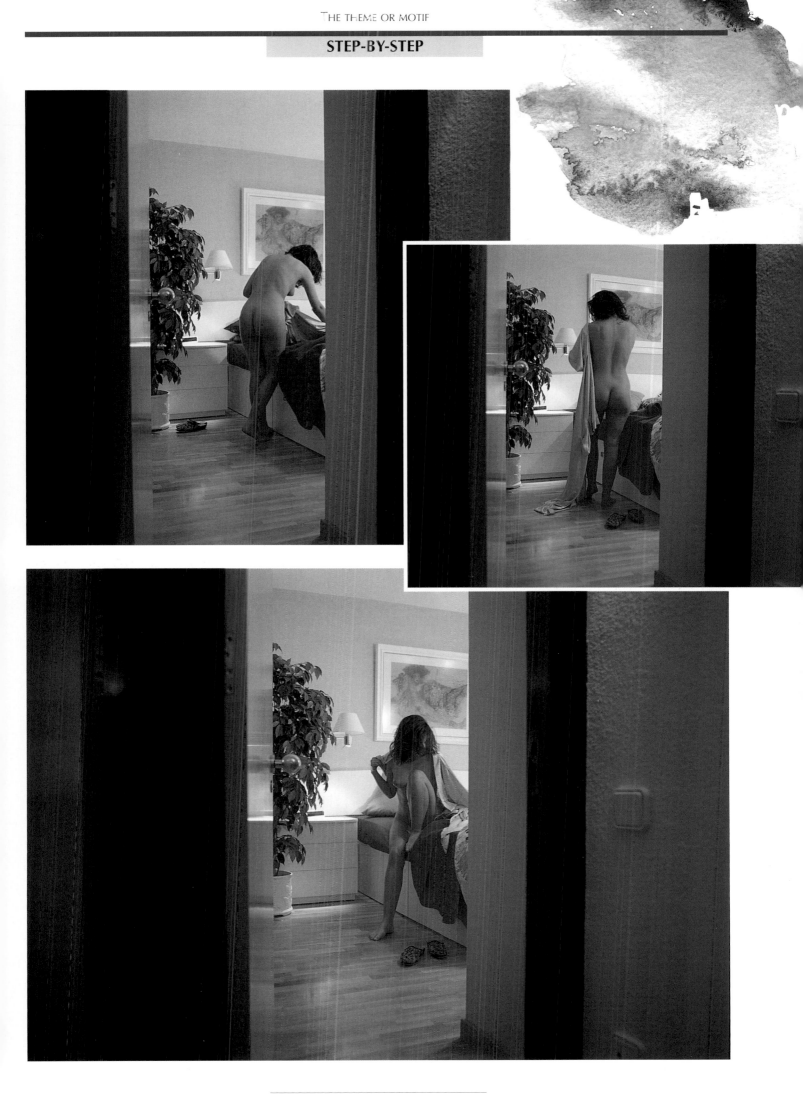

STEP-BY-STEP

DOING SKETCHES

From the collection of photographs, I selected to do sketches that come close to what I would want to do in the painting. We can think of these sketches as a warm-up that will be of great help to me at the time of painting the work. From them, I will make a study of the light, of composition, what to avoid, what to correct and what to subtract. These sketches are in advance of the work to come. At first sight, they can be thought of as a waste of time, but the brushwork we see in the sketches reveals to us their importance to the paintiing yet to be done. Preliminary sketches can never hurt you; they can only help.

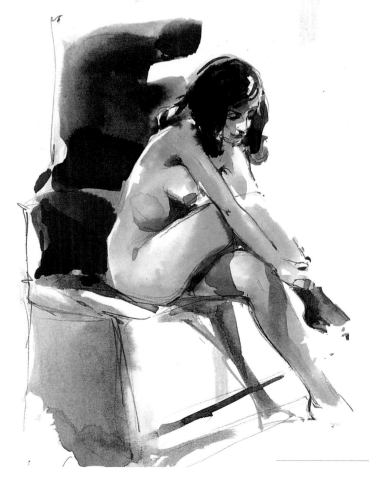

STEP-BY-STEP

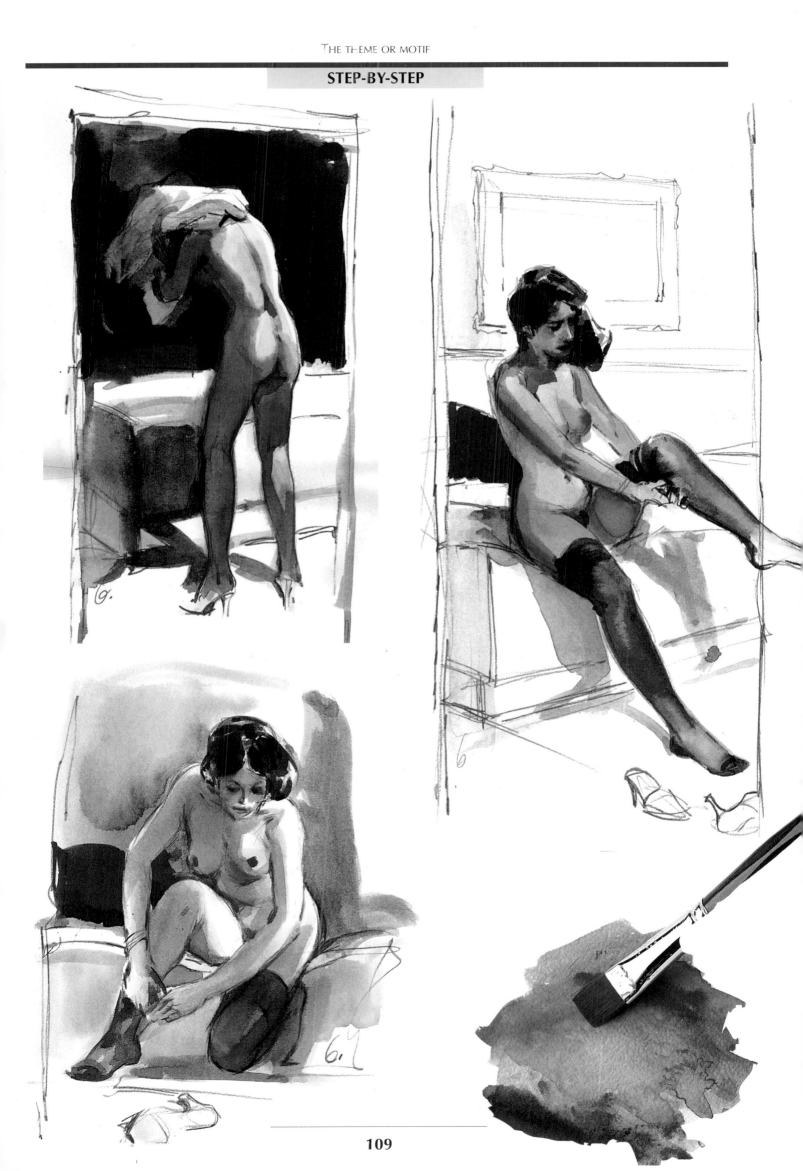

STEP-BY-STEP

PAINTING THE WATERCOLOR

Everything that went before the actual painting was not the result of only one session, nor one day. It's work that has been carried forward over a number of days. To completely capture a figure, I had to decide which photo I was going to interpret, then, it took time for me to make sketches. That done, I am ready to paint.

The nude doesn't occupy the whole composition; the figure is sketched from the outside of the room in a sketch that reminds us of the compositions of painters like Degas and Bonnard, who were painters of interiors and of figures who appeared to be surprised to be caught in their intimacy. The figure in my painting is not a professional model. She's a young woman who agreed to be photographed in her home in an intimate attitude that was not academically posed.

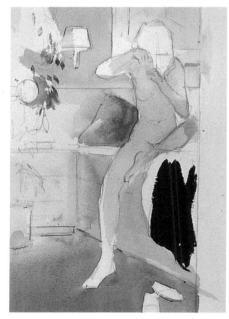

1 As I have just stated, I've kept the drawing free of details. I limit myself to draw the contours of the figure with an almost continuous line and overall to mark the boundaries of the areas for the composition, establishing the relative sizes of all the elements.

2 Initially, the work concentrated on the interior of the room. I began to color the floor with Yellow Ochre and the wall in the background with a very rose color. On the floor the color is much more saturated than in the background wall. I have respected the contours of the figure, the bed and the plant. This provided me with the nucleus for the composition.

3 In this very early moment of work I look for pure contrasts to compare the effect that produces their placements. This is seen clearly in the way in which I have colored the bedspread of the bed, the plant and including the figure. The base color of the figure is the same tone I used for the background of the room but with the major addition of Burnt Sienna, which makes it much warmer.

■ **HELPFUL HINT**

In this composition I have sketched my work with little detail. I centered the composition between dark masses to emphasize the illuminated tones in the center of the watercolor, making it plain that she is being viewed from outside her room.

STEP-BY-STEP

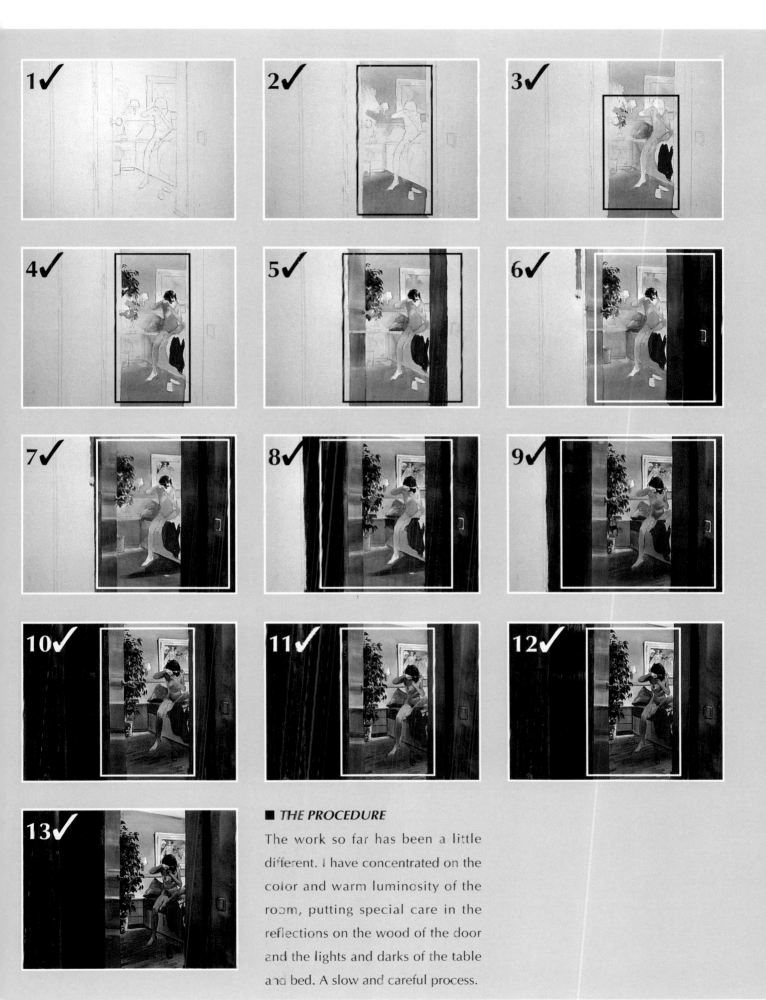

■ *THE PROCEDURE*

The work so far has been a little different. I have concentrated on the color and warm luminosity of the room, putting special care in the reflections on the wood of the door and the lights and darks of the table and bed. A slow and careful process.

STEP-BY-STEP

4 I now begin to look for details like the leaves of the plant. Using small touches of color from the point of my paintbrush, I am trying for an impressionistic look. The figure also begins to see itself more developed thanks to light shadows of Burnt Sienna and the dark violet that represents her hair.

5 Now it's time to work the dark margins of the composition. The main problem here is that these dark tones have to remain separate from the focal point, but the color has to contrast with the clarity of the bedroom.

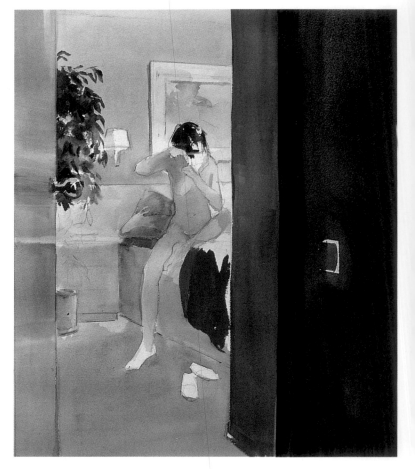

6 Before beginning to look for more details and major realism in the figure, I occupy myself with the dark bands that are the door, to the left, and the trim of the wall that deepens toward the background of the room. The door I paint in a Raw Sienna tone, reducing the brights and reflections of the interior light of the bedroom. Meanwhile, I have already given the plant its total form.

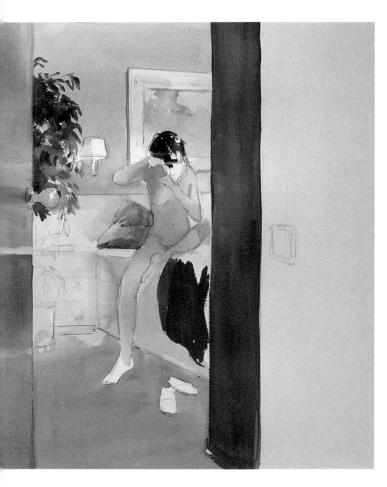

STEP-BY-STEP

7 The watercolor is gaining rich luminosity, thanks to the inclusion of shadow (on the floor, under the bed) and also reflections (in the illuminated part of the door to our left). But what interests me most at this moment is to get a meaningful effect in the shadow, the effect that the action is seen in reality from outside the room and across from an open doorway.

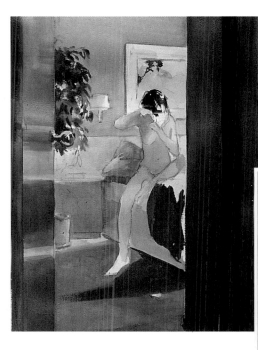

8 This almost black color on the left is the darkest tone of the composition. The strong contrast moves me to favor all the brights of the door. The technique to get these bands of luminosity that represent the reflections of the brights in the room, is to pass a damp and clean paintbrush horizontally over the color to get this effect.

9 Reaching the point to give play to the darker colors, I return to concentrate on the room and the figure to add more detail. The process of modeling the anatomy of the figure is delicate: gentle colors of shading in the torso, the belly and the calf. Together with the figure I have worked some tones of the bed and have graduated them in the same way as the strength of the light of the scene provides to the right of the room.

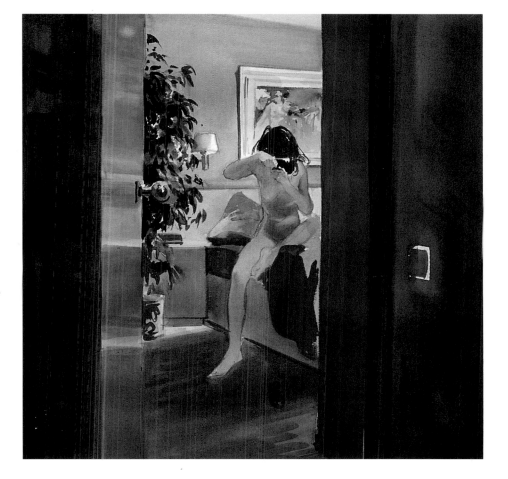

STEP-BY-STEP

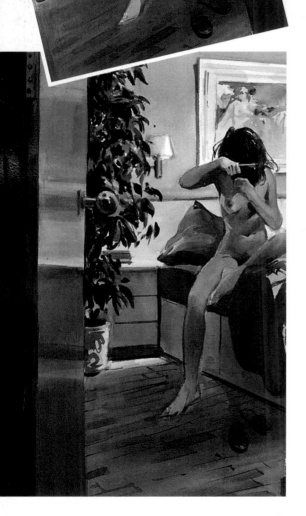

10 While I adjust the tones and look for new ones in the interior of the room, I see with great clarity the direct effect of the light that enters in the background. The painting on the wall, with its clear color, contributes to this effect. The shades of the plant have now been enriched with new mixes of green and with details in the decoration of the pot. At the same time the brights of the floor show up clearly.

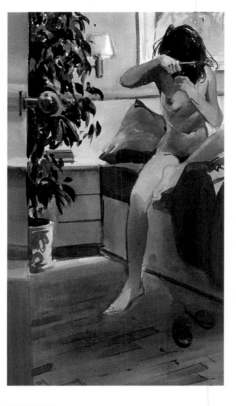

11 After looking over the background, I see that there still remains some major modeling to do in the figure. A careful work of shading has permitted me to clarify all the anatomy without it overwhelming the composition. In fact, the level of finishing the figure and the background is the same.

12 I will get more and more precise on the total watercolor, thanks to the work on all the color. The floor is dark enough. Using a clean and damp sable brush, I will clarify the colors to convincingly represent the slats of wood on the floor. Here, as in the door, the luminous effect is crucial to give richness of textures to the total composition.

STEP-BY-STEP

13 This is the finished watercolor. I am especially satisfied with the luminous effect that I've achieved. I believe that this has been the key to the exercise. To get a focal point that receives interest, the contrast between the warm luminosity of the room with the cool darkness of the exterior of the room should be clear and different. And it is this contrast that gives the work its intimate, sensual and pleasant atmosphere.

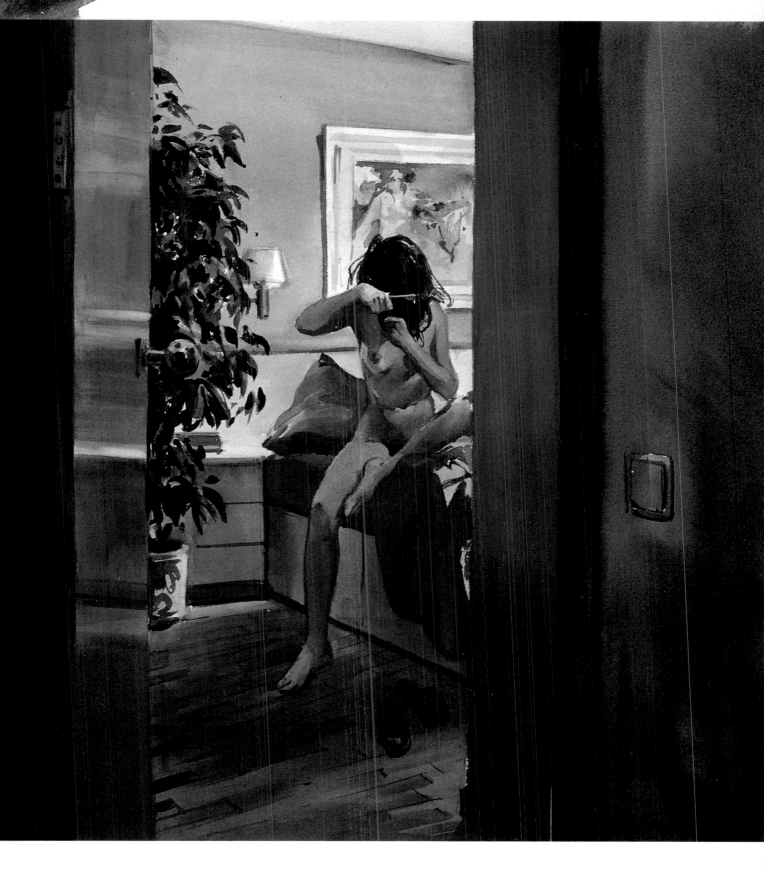

STEP-BY-STEP

How Different Artists Interpreted Dancers

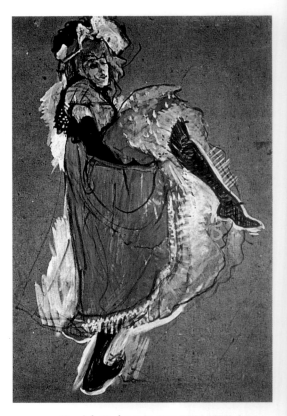

As this book draws to a close, we present a special look at the theater and the people who perform there. We want to stress the importance of the theater, principally the music hall, as the ambiance for actors, dancers and singers. They provide a fountain of material for the painter and over the years, they have pleased all the people who have viewed the paintings.

Therefore, we have chosen a music hall for this section of the book. While the cabaret doesn't have as much popularity as it once had, its fashionable air and its bohemian and decadent ambiance, the ingredients that have always distinguished it from any other spectacle stay intact. The chorus line, the dancers, the peculiar dress, the sequins, the feathers, the types of decorations, the light, the colors, the movement, the heat of the public, the orchestra and the scenery, the direct contact, its particular "sexiness," all added to its ambiance.

When we think of the artists of the past who have made the theater such an important part of their *oeuvre*, our minds and eyes go immediately to the gifted French painter, Henri de Toulouse-Lautrec, whose work we reproduce here along with other members of the group which so many people have loved and admired—the Impressionists.

Henri de Toulouse-Lautrec (1864-1901), Jane Avril. Niarchos Collection, Paris. In this work the painter gets the essence of Avril, one of the stars of the Moulin Rouge. He knew how to express through simplicity, treated almost like a caricature, the essential values of the dancer. A master in the art of observation, with a light and rapid hand, Toulouse-Lautrec captured the movement and the rhythm, with a brilliant touch of calligraphy.

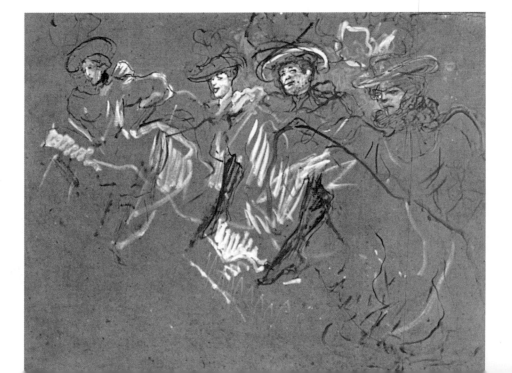

Henri de Toulouse-Lautrec (1864-1901), The Ballet of Mlle. Eglantine. Private collection. Here we see the spirit and the sensation of truly stopping the moment. This work raises a very particular accent of animation, elegance, and grand characterization. It is a brilliant sketch of an instant that's full of rhythm and freedom.

STEP-BY-STEP

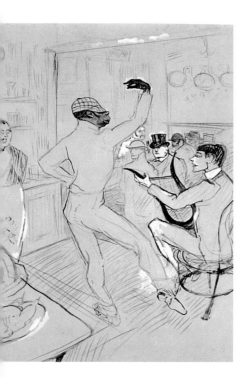

Henri de Toulouse-Lautrec (1864-1901), Chocolate in Full Dance. Toulouse-Lautrec Museum, Albi. This work, at left, is all about the vague sentiment of mystery that gives life to a grand part of oriental art, which the artist greatly admired. The dancer is viewed in a way that reduces to a line the function of the features. With a total perfection of expressive means, the artist has captured the immediacy of a scene, which has provided great idealization.

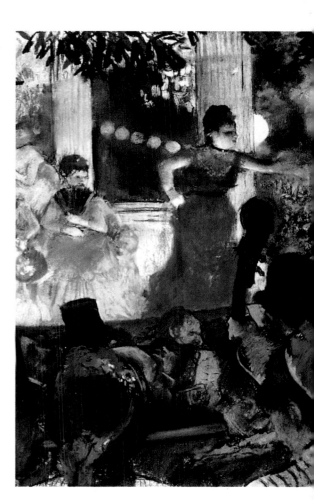

Edgar Degas (1834-1917), The Cafe Concert for Ambassadors, pastel. Museum of Fine Arts, Lyon. Shown in the 3rd Impressionist Exposition of 1877, this picture, at upper right, was criticized for its composition and its classical and daring posture. This work, which broke the traditional molds, captures more than a person, but an ambiance.

George Seurat (1859-1891), Study for Le Chahut, oil on wood. Courtauld Institute Gallery. With his particular style of pointillism, Seurat represents a dance scene of a can-can. It is a simple work, but perfect in composition, in which the artist gets an almost juggled rhythm and movement in the dancers.

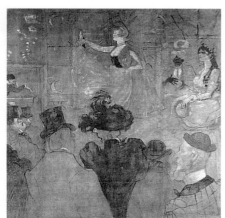

Henri de Toulouse-Lautrec (1864-1901), The Dance in the Moulin Rouge. D'Orsay Museum, Paris. The spontaneity and unfinished quality of this piece that features La Goule, pictured above, are not obstacles to what the artist transmits to us as an instant in which he captures the character of the locale, without forgetting every intimate detail.

Henri de Toulouse-Lautrec (1864-1901), Marcelle Lender Dances the Bolero in Chilperic (detail). Whitney Collection, New York. Shown at right, we see the dancer's character. Despite an apparent spontaneity, all is perfectly studied, nothing is wasted: the position of the leg, the movement of the dress, the inclination of the body, the arm, the rhythm of the petticoats. The theatrical lighting, which the artist exploited, does much to complete the flavor of the moment.

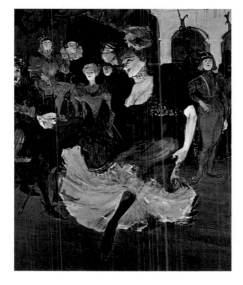

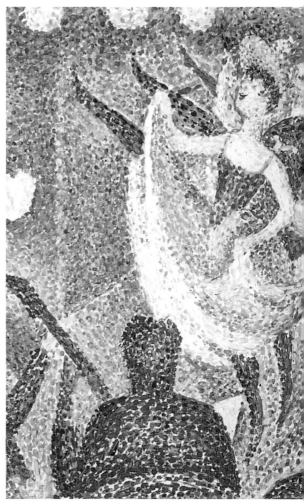

STEP-BY-STEP

Painting the Can-Can

OBSERVING THE MODELS

As we did in our project of the nude in her bedroom, a few pages back, we will now attempt a much more complicated composition—dancers on stage. Our interest in this painting is to capture the spectacle of light, color, movement, rhythm, the decor, the costumes, and the audience. I truly want everyone who sees the finished painting to feel like a member of the audience.

On these two pages, you can see eight photos, from different viewpoints, that give you a very good idea of the spectacle that filled the stage when our photographer snapped the action. This particular series of photos was of the can-can, an exciting dance routine that is universally popular.

Look over the photos and study them. Then, you can go on to the next phase—the sketches that I made in preparation for the third and final phase of this series.

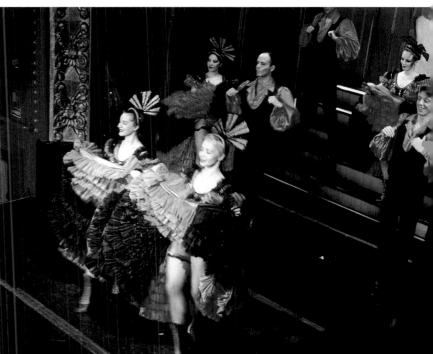

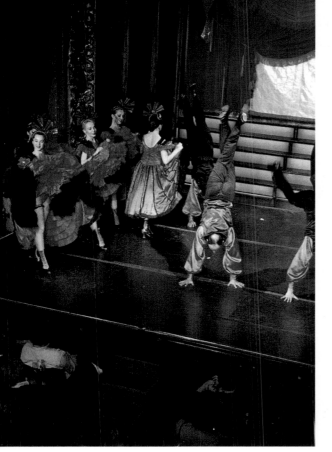

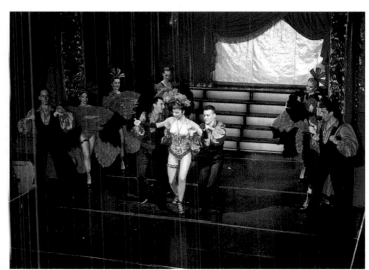

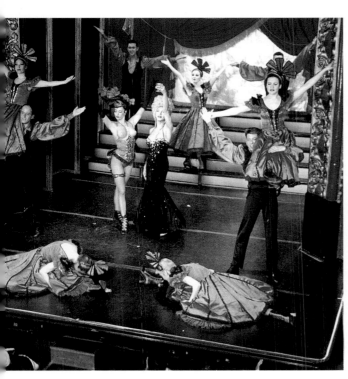

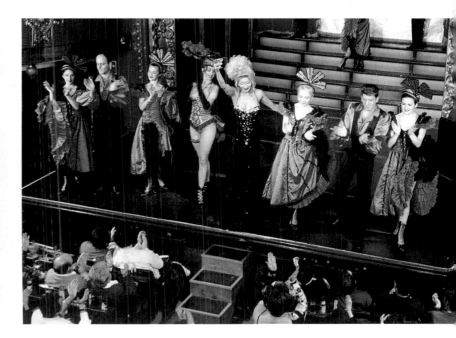

STEP-BY-STEP

DRAWING SKETCHES

Unlike a static pose, that we can make last as long as we want, the situation of dancers on stage is very different. The movement is alive and constant. As fast as they move, though, the eye has time to capture an instant through images appearing intermittently. More than images, we capture sensation, throbbing light, physical features, all that constitutes the base material for sketching and the realization of rapid notes. They are elements that serve our memory and that will help our imagination to profile that which is stored in our subconscious.

I offer here a collection of my sketches, some of them drawn instantaneously and others with more work added later on. The quantity of sensations of this type of locale wakes in me a creative volcano which has to erupt. In this example, I want you to appreciate how all the sketches are pieces of the panorama. They are the ones which later serve me for the major work to which I feel obligated to paint in all of its movement.

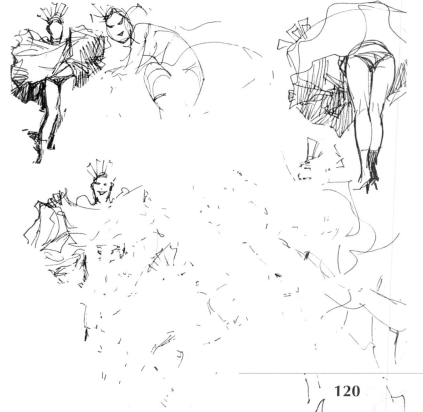

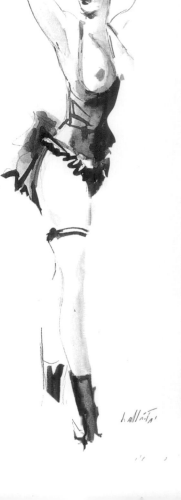

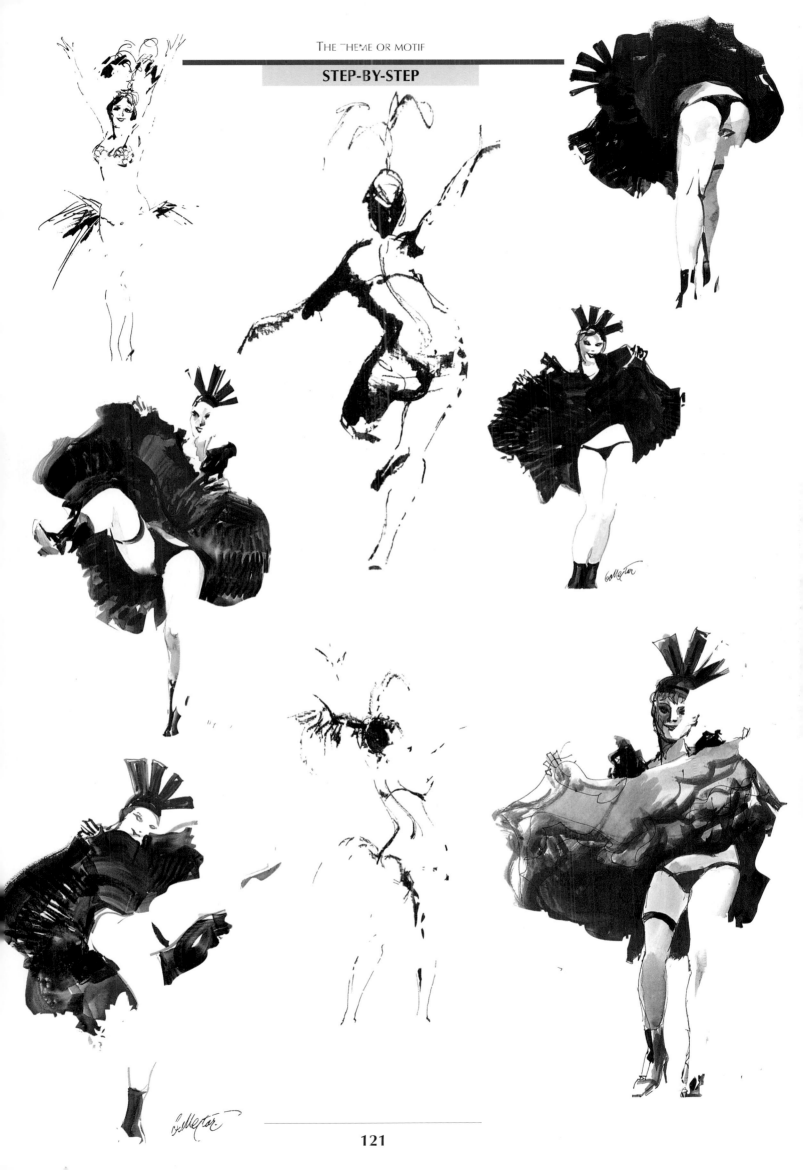

STEP-BY-STEP

PAINTING THE WATERCOLOR

Up to this point, the development of this work has been meticulous and well organized. Now I am prepared to finish this demonstration. It's important for me to emphasize that I am not interested in copying one of the photographs, but making the figures look human.

The brightness of the dancers' dresses lit by the spotlights, the dance steps and the dancers' expressions are aspects that no painter can deny. My motive was to gather the maximum of local color in this watercolor, recreating a cabaret at night, including the heat of the audience that is at feverish heights at these live performances.

1 After doing the drawing, I saw that I could almost consider it a finished work. Having outlined some central figures, with my focal point in place, I could consider my drawing as perfect as I could get it as the foundation for my painting. At this juncture, I feel secure in its function as a guide to paint the work with color.

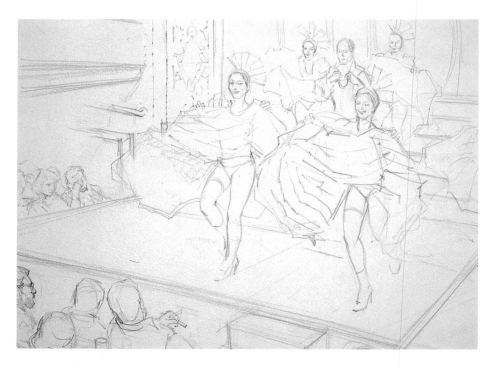

■ *THE PROCEDURE*

I made many drawings and took lots of notes before this step-by-step, and have studied the drawings along with the color notes. This is valuable because it's obvious that the key is red in all the tones and intensities. In these reds are unfolded light and shadow. The darkest tone is where the dancers' bodies stand out; this is the focal point.

STEP-BY-STEP

■ *HELPFUL HINT*

When painting a picture like this one with its dark intense colors, it is necessary to contrast these colors with lighter, brighter ones, such as the flesh in the legs.

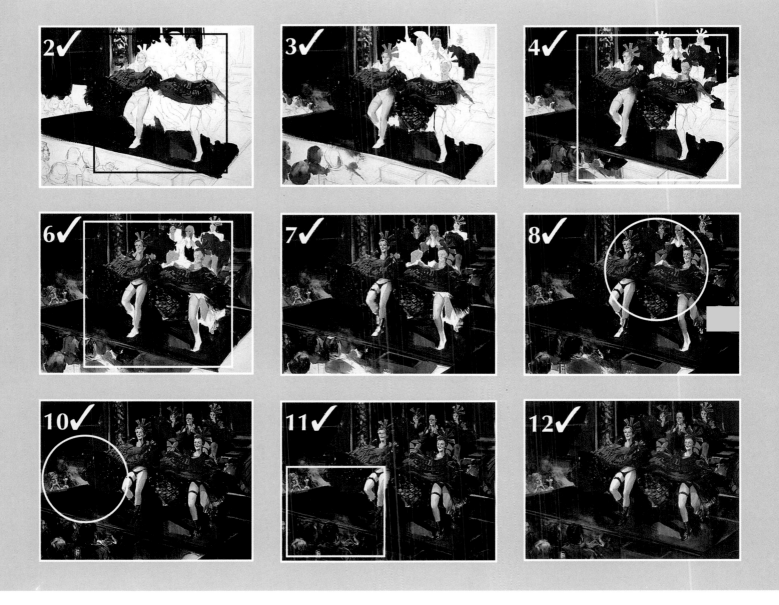

2 I search for blocks of the same color. One of these blocks, the one that's most stressed, is of the folds in the skirts raised high by the chorus. Its drawing isn't as difficult as it seems: from an intense Alizarin Crimson, lightly modeled in the principal levels, over which I have worked with a somewhat dry paintbrush of pointed red sable, stroking the small shadows that create the pleats. The effect is very dynamic.

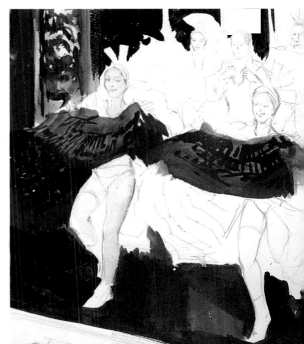

STEP-BY-STEP

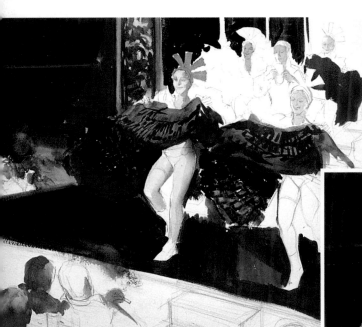

3 The contrast between blocks of color is more of tone than of color itself. All the blocks come from red. Alizarin Crimson in the dresses, deep violet in the scenery and Cadmium Red Medium in the stage. The contrast of these reds with the gold of the decoration gives the tone a remarkable theatrical quality to the painting.

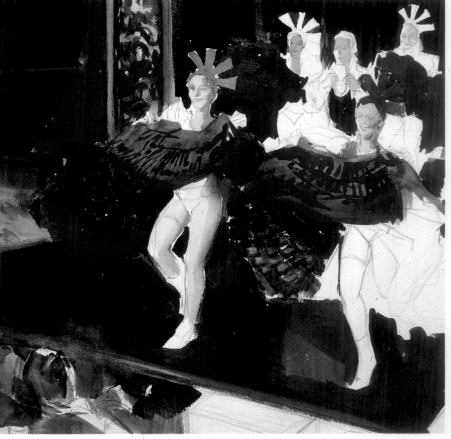

4 Now I am working with the figures in negative, in effect painting around them, and leaving for later the complicated hats and touches that adorn the dancers. Here I am more interested in pure coloring. The pure color that is created from the intense green of the steps to the right, promotes a strong complementary contrast (red and green).

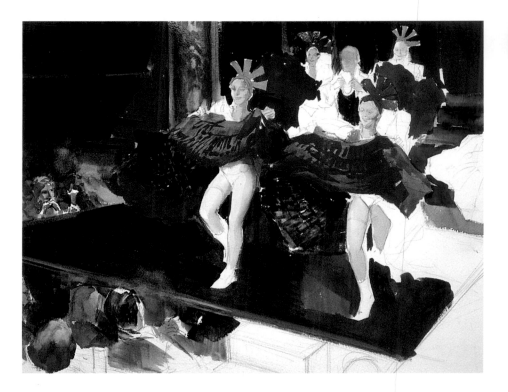

5 Between the dark masses of the skirts, the brights of the modeling of the legs stand out. As I said before, it is in the body of the chorus where the main thrust of this painting is found. The reds and intense red violets are a perfect counterpoint to the clarity and softness. The audience begins to appear in a subtle manner, vaguely drawn, so as not to compete with the authentic stars of the work.

STEP-BY-STEP

6 The effect of the illumination is very interesting, because the intense shadows only affect the last level of the composition; the dancers are put in without the necessity of modeling and clouding the color of the fleshtones. To the side, at the left of the composition, we can see another interesting fragment: people in the audience.

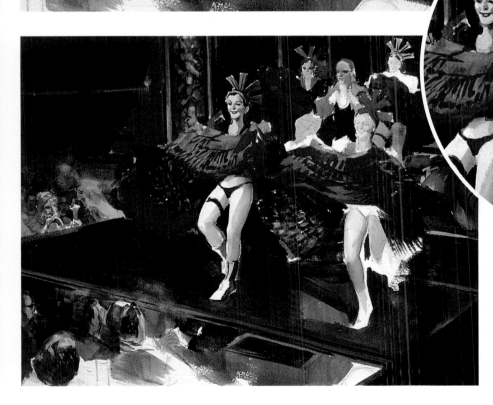

8 Each dancer is characterized. Some touches of color have been added to define the features. In painting theater scenes, the abundance of makeup permits the painter a simplified and emphatic version of the facial features. The dancers' bodies in the first line are more detailed than the ones behind them.

7 Color now covers the paper completely and thus I am satisfied with the tones in the painting. I am satisfied also with the illumination. This has been a work of contrasting brights against darks, always making sure that the scenery receives the most outstanding contrasts outside of the group of figures The group is complete, dancing to the same sound, dynamic and spectacular.

STEP-BY-STEP

9 In these final phases, I have occupied myself with the shadows over the wooden planks of the scenery. These cutaway shadows are dynamic because they interrupt the continuity of the maroon color creating a strong silhouette. Moreover, the shadows accent the luminosity that falls on the figures.

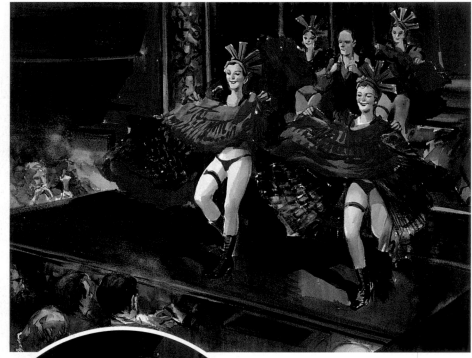

10 The watercolor is almost finished except for the audience. There is a group that smokes and drinks in the first row of the orchestra section which may seem odd to some readers. This theater is in a city in Spain where smoking and drinking are permitted. There is a lot of smoke. I intend to represent it with color to simulate a light cloud.

11 The final work on the audience: a hand holding a cigarette, a profile that is drawn between the puffs of smoke. All this is in a minor tone, without contrasting and differentiating the forms further.

STEP-BY-STEP

12 I am satisfied with the finished result. Above all, I am satisfied at
having been able to make you be a part of my enthusiams in the
endless field of figure painting in watercolor. The next work will be up to you.
Gather your paints and good luck!

INDEX